MANET
TO PICASSO

THE NATIONAL GALLERY

NATIONAL GALLERY COMPANY, LONDON
DISTRIBUTED BY YALE UNIVERSITY PRESS

MANET
TO PICASSO

THE NATIONAL GALLERY

First published in Great Britain in 2006 by
National Gallery Company Limited
St Vincent House
30 Orange Street
London WC2H 7HH
www.nationalgallery.co.uk

ISBN 10: 1 85709 333 X
ISBN 13: 978 1 85709 333 9
525497

British Library Cataloguing-in-Publication Data
A catalogue record is available from the British Library

Publisher Kate Bell
Project Editor Tom Windross
Designer Joe Ewart for Society
Production Jane Hyne and Penny Le Tissier

Colour reproduction by DL Repro, London
Printed and bound in Hong Kong by Printing Express

All measurements give height before width

37 Vuillard © ADAGP, Paris and DACS, London 2006
38 Picasso © Succession Picasso/DACS 2006

Contributors
CA Charlotte Appleyard
SH Sarah Herring
NI Nancy Ireson
CR Christopher Riopelle
AR Anne Robbins

Front cover: **Claude-Oscar MONET**, *The Water-Lily Pond* (detail, plate 6)

CONTENTS

Introduction

The National Gallery's Impressionist, Post-Impressionist and Early Modern paintings are among its most popular. The rooms in which they hang teem with visitors for whom Manet's *Music in the Tuileries Gardens* and Van Gogh's *Sunflowers* are 'destination' pictures, works of such fame and importance that art lovers from around the world make their way to stand in front of them in rapt admiration. Tour guides speaking English, French, Japanese and, increasingly, Russian and Chinese too, among many other languages, explain the intricacies of Seurat's monumental *Bathers at Asnières* to hushed groups of tourists. Squadrons of school children, for whom an excursion to the National Gallery is a highlight of the academic year, hurry home to tell family members that they have seen Henri Rousseau's fearsome tiger in *Surprised!* and then return to Trafalgar Square, parents and siblings in tow, to wonder at it again. Cézanne's angular *Bathers* continues to startle, a herald of the most audacious innovations of twentieth-century painting and a warning near the end of the chronological circuit that visitors can follow at the Gallery that epochal changes in art were underway.

That such paintings were to be seen in Trafalgar Square would have come as a surprise, and an occasion of distress, for many people a century ago. The National Gallery represented the finest in the long, subtle European painting tradition. It housed masterpieces of the Italian and Northern Renaissance, sublime works by Rubens and Rembrandt, Poussin and Claude. The jarringly highly coloured and aggressive works of the modern 'art rebels' as they were dubbed – for the most part Frenchmen, which was bad enough, but surely anarchists or worse as well – had no place in its august, gilded rooms. In 1907 the Trustees let it be known that an attempt to raise a subscription and present the Gallery with a painting by Claude Monet, *Lavacourt under Snow* of about 1878–81, would not meet with success. A Degas canvas was also found wanting and turned away. Soon after, Sir Hugh Lane offered his distinguished collection of modern paintings, including *Music in the Tuileries Gardens* and Renoir's *Umbrellas*, on long-term loan here and was rejected. It seemed that the Gallery's magnificent display of pictures would crawl to a chronological halt somewhere in the early decades of the nineteenth century, at a sanitary remove from the modern world and its discontents.

Slowly, although not always gracefully, things began to change. In 1914 a report by Lord Curzon, a Trustee, called on the Gallery to form a collection

of modern foreign paintings. In 1915 Lane went down on the *Lusitania* and it was discovered that in his will, about which the Trustees previously had known nothing, he had bequeathed 39 modern paintings to the Gallery, including works by Manet, Renoir and Degas, among them, ironically, *Lavacourt under Snow*. A few years earlier, in 1913, the Trustees had finally agreed to take Lane's pictures on loan but then decided among themselves that only some of them would actually be shown. When Lane found out, he was offended by what he saw as high handedness and wrote a codicil to his will leaving the pictures to Dublin instead. The document was found after his death in his desk, but because unwitnessed it had no status in British law. Thus, during the Great War the National Gallery found itself in possession of modern and contemporary paintings (including some by living artists), some of which it did not entirely approve of and intended not to show but which, under its strict mandate, it was not free to discard. It also found itself at loggerheads with an aroused Ireland, gearing up for its struggle for independence from Britain, which felt it had a strong moral claim on the works. More than 40 years of acrimonious dispute followed – Lane's aunt, the indefatigable Augusta, Lady Gregory, a beacon of the Celtic Revival, pressed the Irish claim – before a compromise was reached which saw the majority of Lane's collection go on permanent loan to the Dublin City Gallery The Hugh Lane. The eight most important masterpieces, including *Music in the Tuileries Gardens*, began a permanent rotation between London and Dublin. Currently, they travel back and forth in groups of four every six years.

Degas died in 1917. The following year the collection he had assembled of works by himself and by the contemporaries he most admired was sold at a series of auctions in Paris while war raged in the Parisian suburbs. By then others, such as the critic Roger Fry and economist John Maynard Keynes, were convinced of the significance of modern French painting, and the latter persuaded the government to make funds available to allow the National Gallery to bid at the Degas auctions. The Gallery Director, Sir Charles Holmes, led a delegation to Paris and later recalled the sound of cannon fire as he bid; he also recalled French consternation as he vied for pictures against the Louvre. The Degas auctions marked the beginning of the Gallery's firm commitment to forming a collection of modern Continental paintings. Thirteen works were acquired including major canvases by Ingres and Delacroix. A vivid Tahitian-period still life by Gauguin whom the aged Degas had championed also entered the collection. Degas's own painting, the fiery *Combing the Hair* of about 1896 – the critic Douglas Cooper called it 'the big red monster' – was on the list of paintings for which the Gallery intended to bid, but was struck off when upon inspection it was decided that the work was unfinished. (In fact it was shown at the auction with a disconcertingly large strip of bare canvas showing at the bottom, subsequently folded back.) It would be almost 20 years before the

Gallery had another opportunity to acquire the painting, it having in the meantime passed through the collection of that master and *afficionado* of high-keyed colour, Henri Matisse.

In 1922 the magnate Samuel Courtauld gave the Gallery the considerable endowment of £24,000 specifically for the acquisition of modern Continental paintings. Before it was exhausted at the end of the 1920s, the Courtauld Fund was used to ensure that major masterpieces entered the collection, not least Seurat's *Bathers* and Van Gogh's *Sunflowers*. The latter was not the first Van Gogh to be acquired by the Gallery, in 1924. Several months earlier the Trustees, increasingly confident in their knowledge of modern painting, had purchased a *Portrait of Postmaster Roulin*, now in the Museum of Modern Art, New York, but returned it to the artist's descendants on exchange, insisting that the great Dutch painter must be represented in London by what was already seen as his signature image, the brilliant vase of golden sunflowers that still sees crowds of visitors gather in front of it every day. (If only they also still had the *Roulin* to admire!) The Courtauld Fund also saw the first Cézanne, a self portrait, enter the collection. From a barely suppressed antipathy for modern painting a quarter of a century before, by the mid-1920s the National Gallery stood at the international forefront in the appreciation and acquisition of modern paintings. From the 1930s onwards, though its finances were straitened, the Gallery continued to purchase, and to receive by gift and bequest, distinguished works of the late nineteenth and early twentieth centuries, making it one of the finest public assemblages of such works. As recently as 1979 and 1982, such masterpieces by Monet as *Bathers at La Grenouillère* and the *Gare Saint-Lazare*, both central to the Impressionist achievement, entered the collection by bequest.

For decades these pictures did not hang in Trafalgar Square but in the Gallery of Modern Foreign Painting at the Tate Gallery on Millbank. The Tate had been founded in 1897 as an adjunct of the National Gallery for the collection and display of British paintings, though a core group of great British paintings always remained in Trafalgar Square for comparison with Continental schools. From the early decades of the twentieth century the Tate showed all of the Gallery's nineteenth-century paintings as well and, after Curzon's 1914 report, additionally assumed responsibility for the more progressive modern paintings. Naturally, the Tate came to chafe under the oversight of the National Gallery. The 1952 Massey Report, prepared by former National Gallery Chairman Vincent Massey, called for the separation of the two institutions and the full independence of the Tate, which came about two years later. The Tate then continued in its dual role, responsible for British, and modern and contemporary art. Most, though not all, nineteenth-century paintings were returned to Trafalgar Square at that time, although a strict divide of the collections at

1900 was always notional rather than scrupulously enforced. An overlap of the two collections in modern, as in British, painting was widely accepted and the National Gallery continued to acquire early twentieth-century paintings by artists primarily active in the previous century.

An important example of the latter came in 1964 with the purchase of Cézanne's *Bathers*, one of three 'Bather' compositions that remained on the artist's easel when he died in 1906. The acquisition was championed by the artist-Trustee of the moment, Henry Moore, who was vehement in his insistence that this great work, the only one of the three to remain in private hands, must come to London. (Artist-Trustees have long played a vital role at the Gallery in looking out for the welfare of the modern collection. Several years later, Howard Hodgkin would insist that the fragments of Manet's *Execution of Maximilian*, acquired at the Degas auctions, should be reunited on a single canvas.) Not all agreed with Moore. *The Times* led an assault on the Gallery claiming it was scandalously wasting public funds (approximately £475,000) on what was obviously the work of a foreign madman. That Cézanne should continue to provoke outrage well into the second half of the twentieth century is a testament not only to the provocation inherent in his art but also to the instinctive ability of the London press to tap into what seems to be a deep vein of British scepticism about Modernism.

In recent years two major developments have begun to alter the shape of the modern collection in Trafalgar Square. Whereas the vast majority of modern works historically have been by French artists, it was determined in the 1970s that a concerted effort should be made to acquire paintings by their European contemporaries, including Germans and Scandinavians. Thus, works have been acquired by, among others, the Austrian Klimt, the Germans Friedrich and Gaertner, the Danes Købke and Eckersberg, the Finn Gallen-Kallela and the Belgian van Rysselberghe. Rarest of all, perhaps, a major painting of 1867 by the German Menzel has entered the collection as the result of its 2005 restitution to the descendants of the Jewish family from whom it was acquired by a German public institution in the dark days before the Second World War. In 1975 the Gallery Trustees also determined that it should begin to build a small, representative collection of major works of the early twentieth century, including paintings by Picasso and Matisse.

If the Gallery's mandate is to trace the story of European painting from the dawn of the Renaissance, the argument went, then nothing happened in or around 1900 to bring that story to an end. Quite the reverse. Like the select group of British paintings on view in Trafalgar Square, these twentieth-century paintings would serve to direct attention to the fuller representation of works at the Tate Gallery, now reconstituted as Tate Britain and Tate Modern.

In 1997 this latter policy was reversed. Most of the Gallery's twentieth-century paintings travelled to Tate Modern while Tate's remaining nineteenth-century paintings came here by exchange. The benefits to the National Gallery were clear. More great Seurats and Gauguins were to be seen in Trafalgar Square while important works by artists otherwise unrepresented, such as Liebermann and Hammershøi, were shown there for the first time. The loss of pioneering twentieth-century works was keenly felt, however, as if a vital thread of continuity in the painting tradition had been sacrificed. Thus, the exchange agreement with Tate Modern remains under reconsideration, part of the on-going debate, now a century old, on the role that audacious and provocative modern painting ought to play in The National Gallery.

Christopher Riopelle

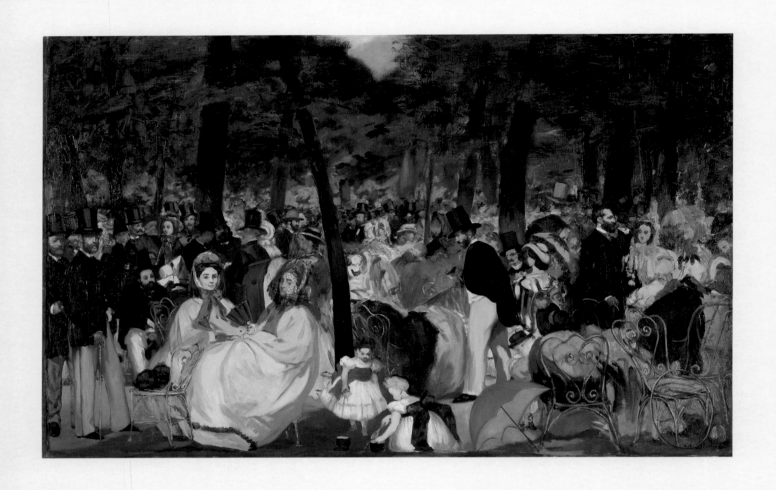

1 Edouard MANET (1832–1883) *Music in the Tuileries Gardens*, 1862

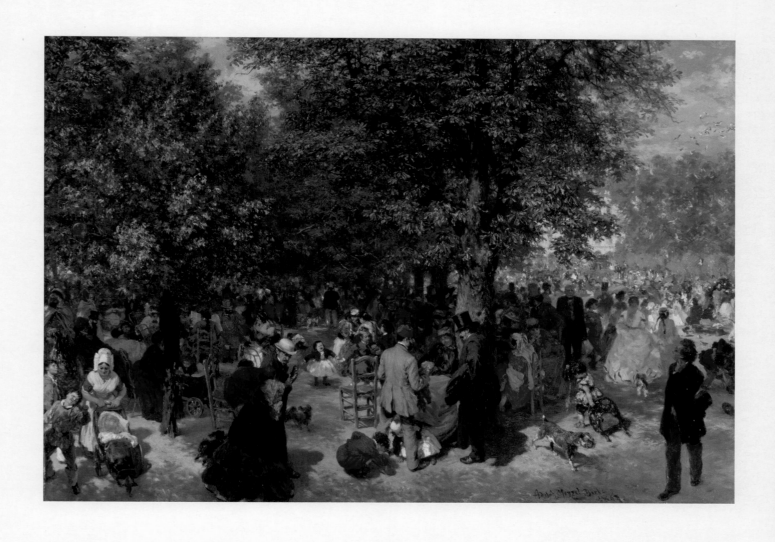

2　Adolph MENZEL (1815–1905) *Afternoon in the Tuileries Gardens*, 1867

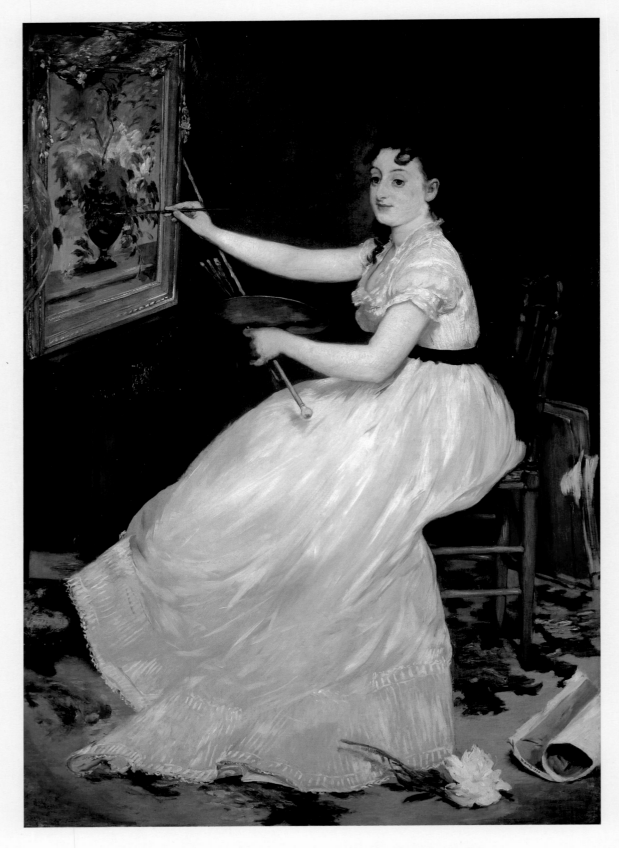

3 Edouard MANET (1832–1883) *Eva Gonzalès*, 1870

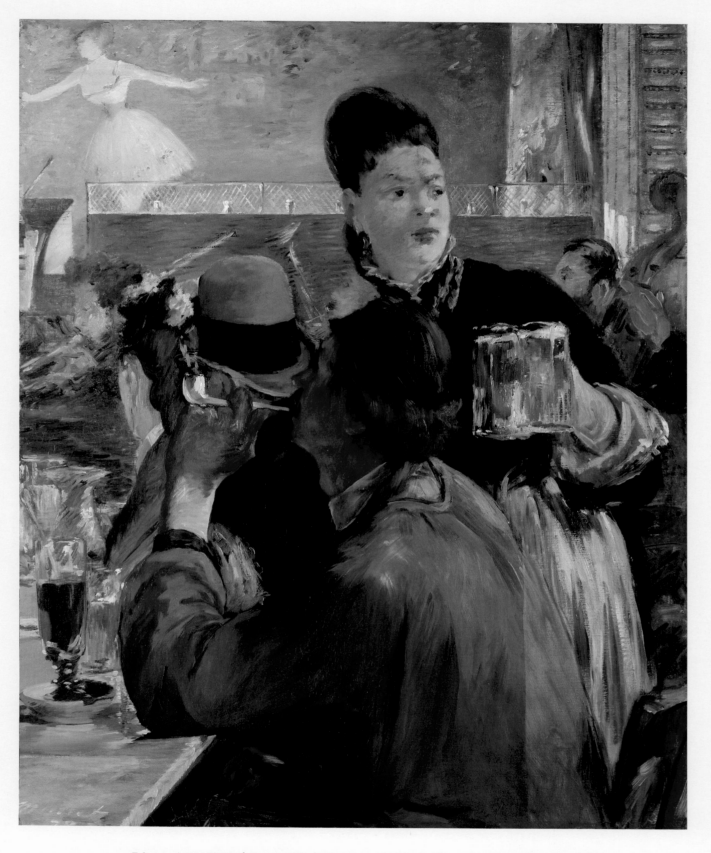

4 Edouard MANET (1832–1883) *Corner of a Café-Concert*, probably 1878–80

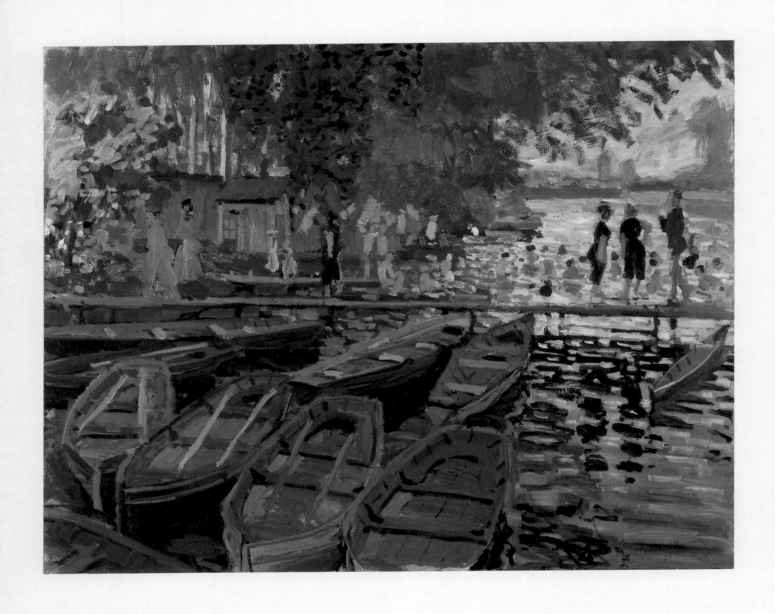

5 Claude-Oscar MONET (1840–1926) *Bathers at La Grenouillère*, 1869

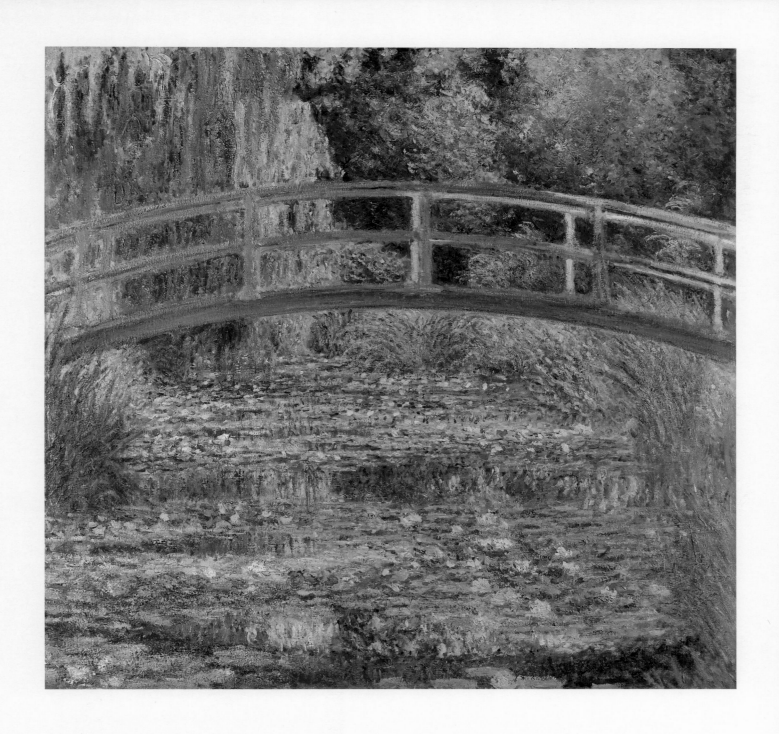

6 Claude-Oscar MONET (1840–1926) *The Water-Lily Pond*, 1899

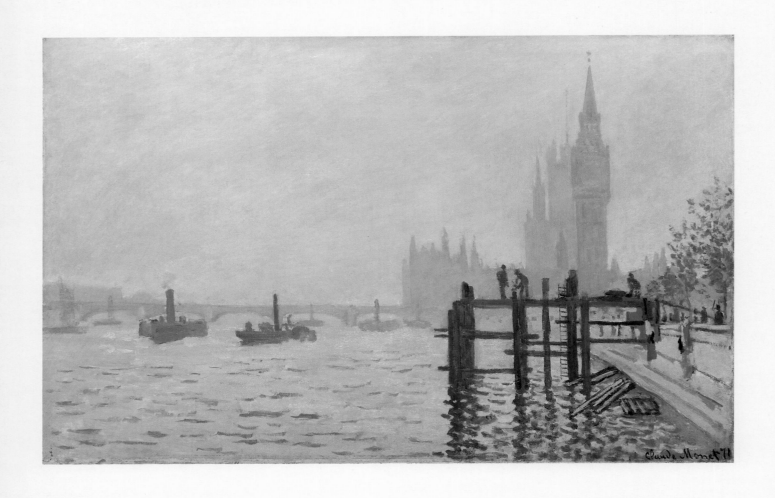

7 Claude-Oscar MONET (1840–1926) *The Thames below Westminster,* about 1871

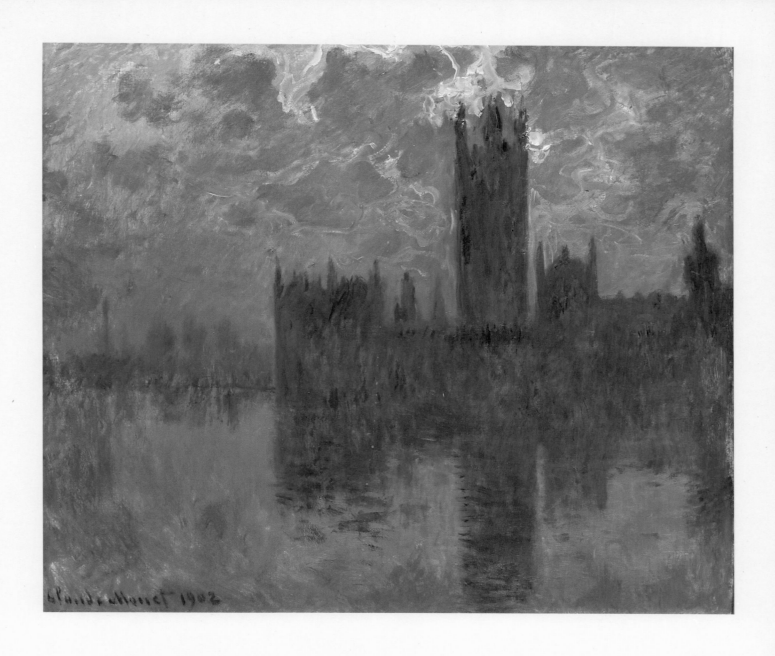

8 Claude-Oscar MONET (1840–1926) *Houses of Parliament, Sunset*, 1902

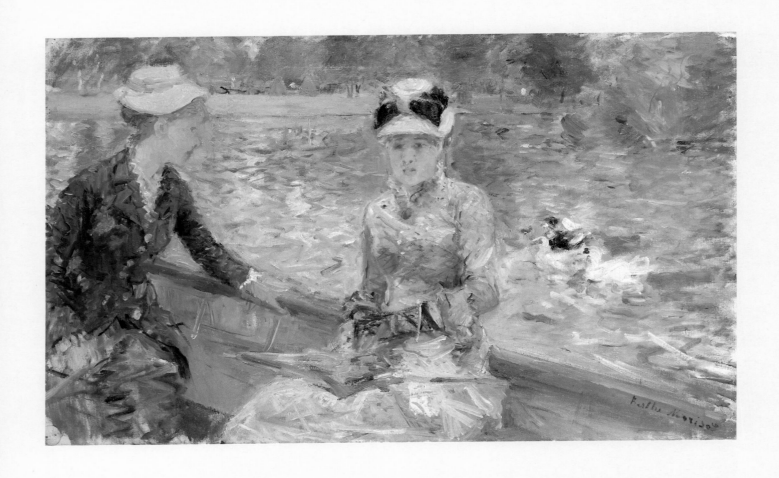

9 Berthe MORISOT (1841–1895) *Summer's Day*, about 1879

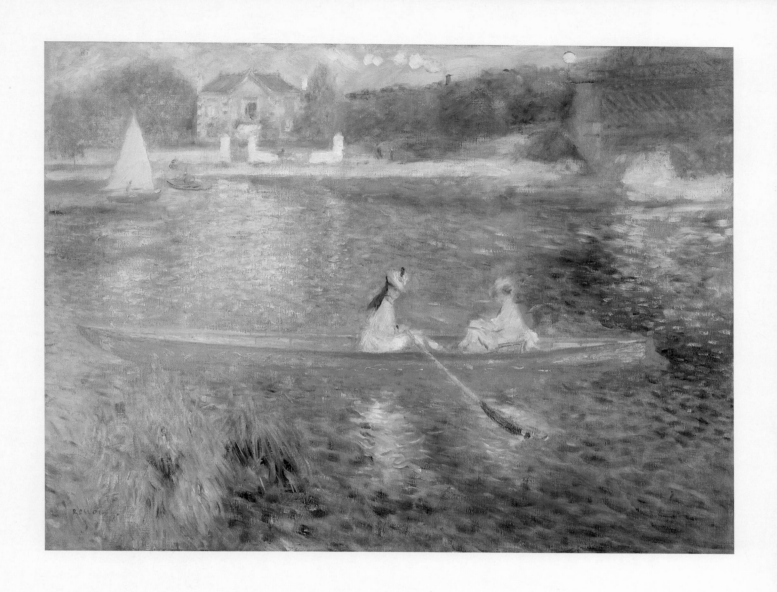

10 Pierre-Auguste RENOIR (1841–1919) *Boating on the Seine*, 1875

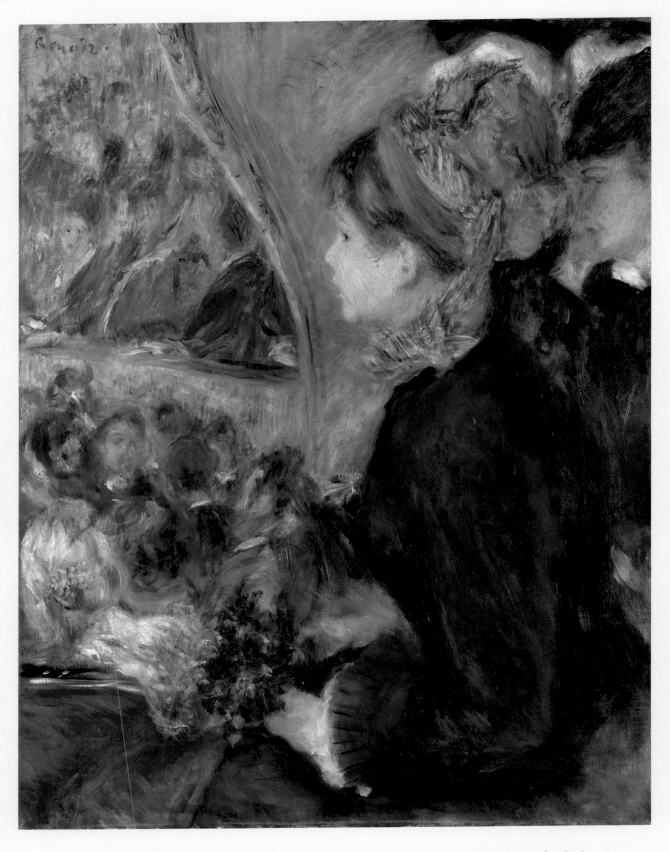

11　Pierre-Auguste RENOIR (1841–1919) *At the Theatre (La Première Sortie)*, 1876–7

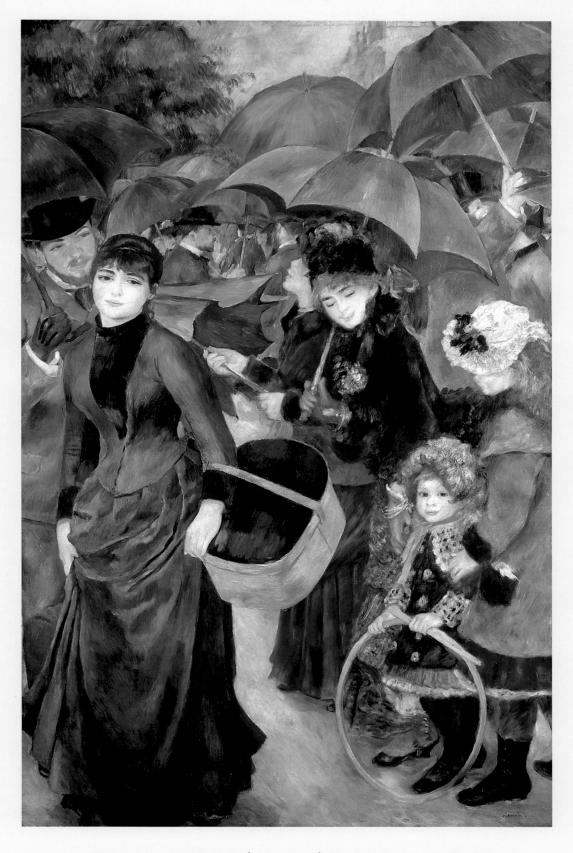

12 Pierre-Auguste RENOIR (1841–1919) *The Umbrellas*, about 1881–6

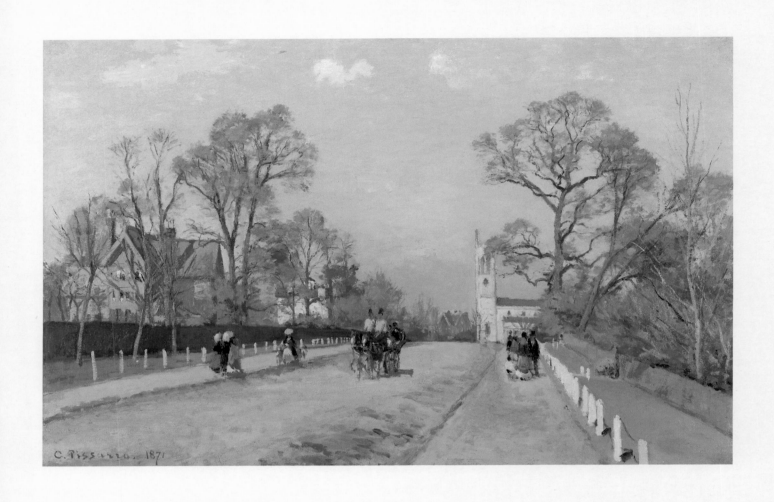

13 Camille PISSARRO (1830–1903) *The Avenue, Sydenham,* 1871

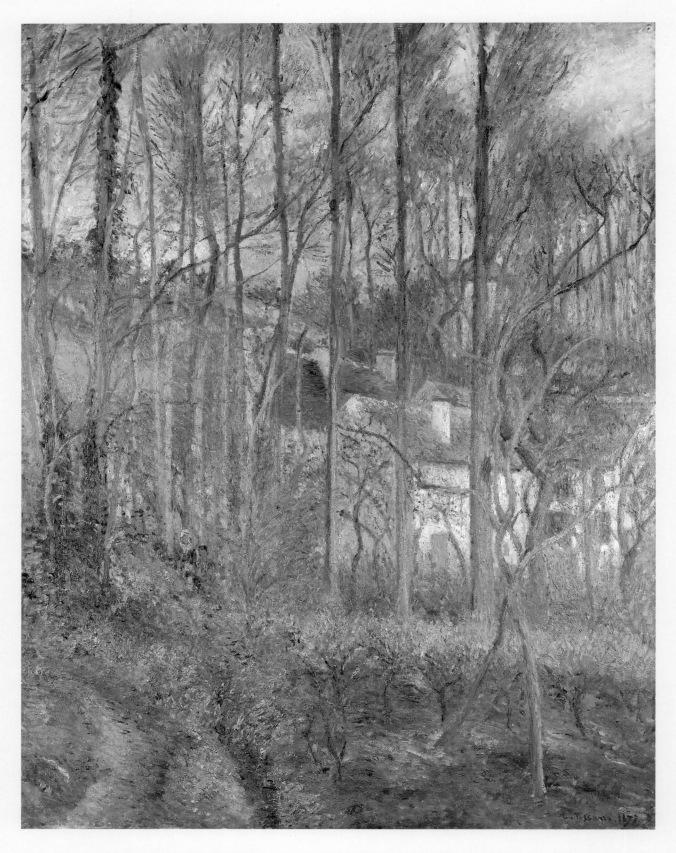

14 Camille PISSARRO (1830–1903) *The Côte des Bœufs at L'Hermitage*, 1877

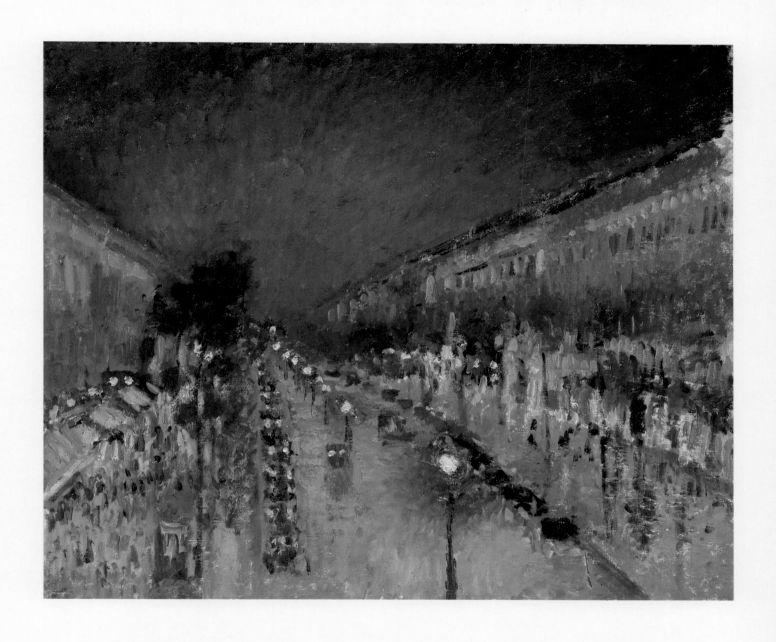

15 Camille PISSARRO (1830–1903) *The Boulevard Montmartre at Night, 1897*

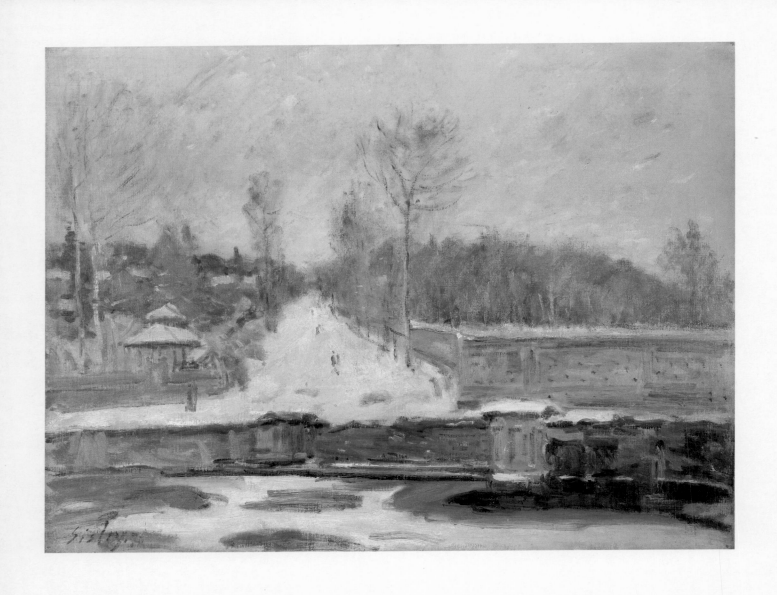

16 Alfred SISLEY (1839–1899) *The Watering Place at Marly-le-Roi*, probably 1875

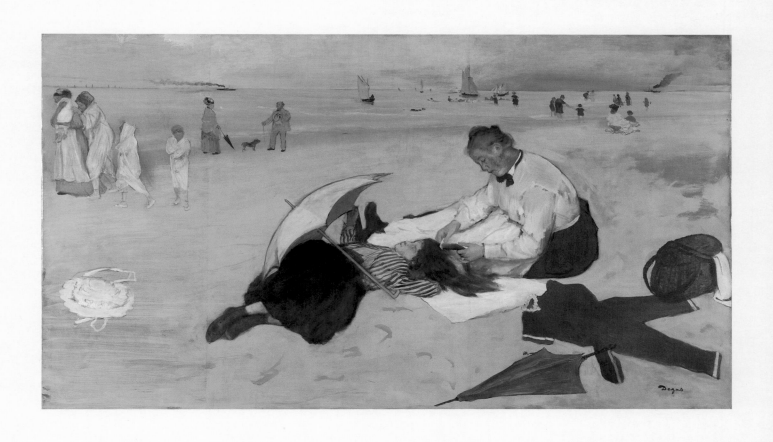

17 Hilaire-Germain-Edgar DEGAS (1834–1917) *Beach Scene*, about 1869–70

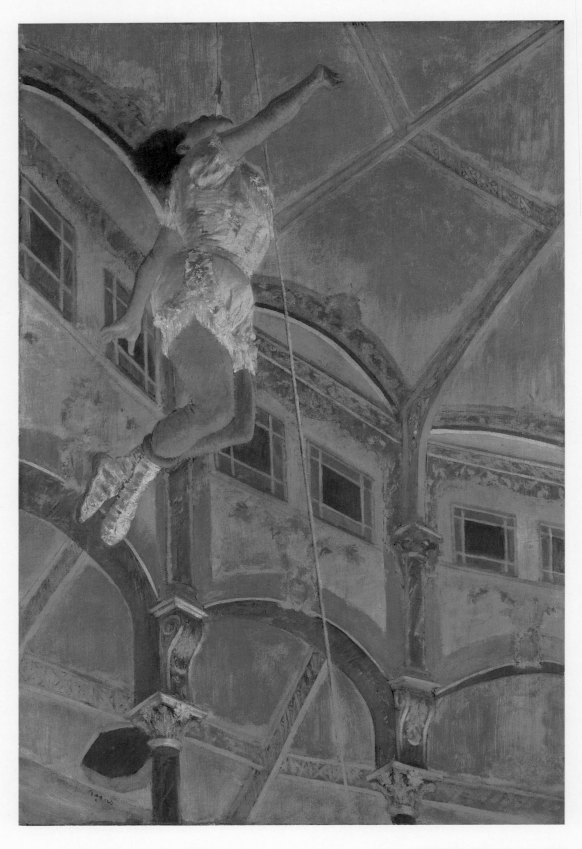

18 Hilaire-Germain-Edgar DEGAS (1834–1917) *Miss La La at the Cirque Fernando*, 1879

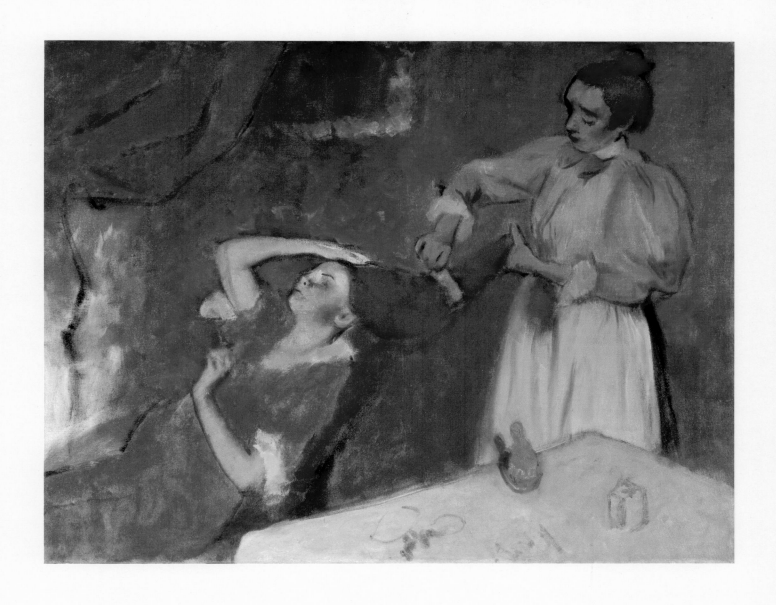

19 Hilaire-Germain-Edgar DEGAS (1834–1917) *Combing the Hair ('La Coiffure')*, about 1896

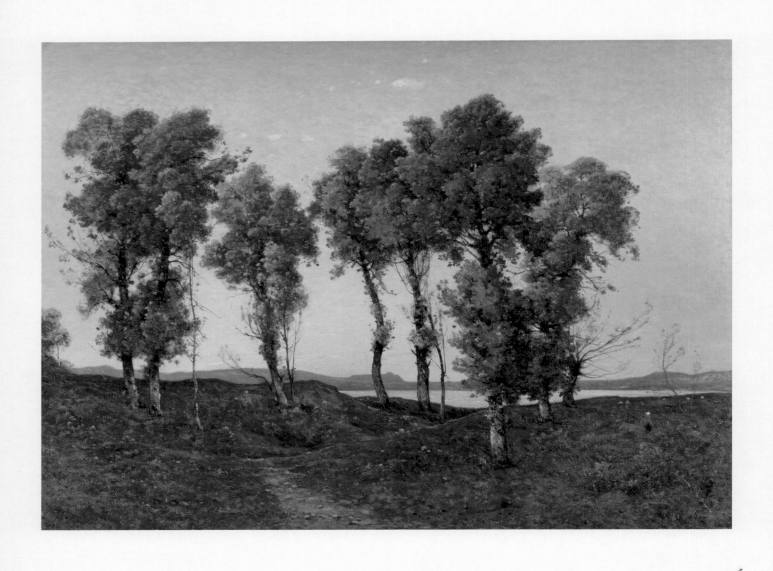

20 Henri-Joseph HARPIGNIES (1819–1916) *Autumn Evening*, 1894

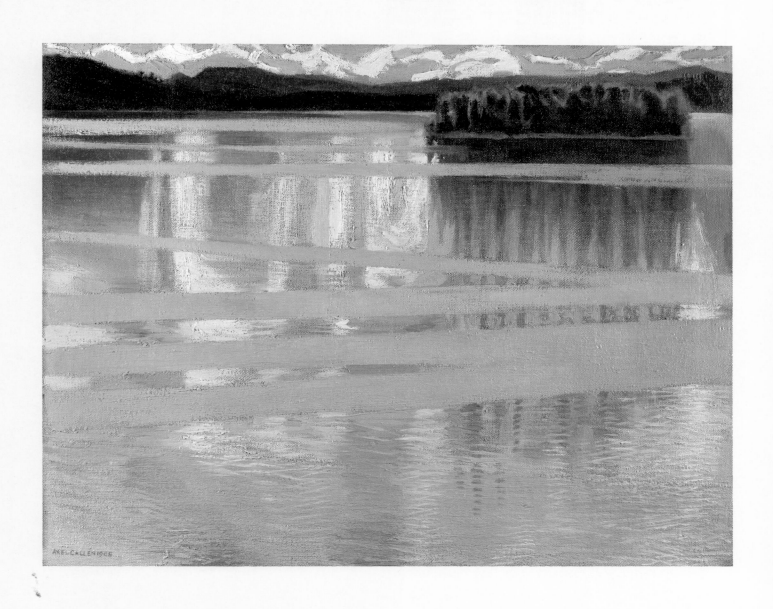

21 Akseli GALLEN-KALLELA (1865–1931) *Lake Keitele*, 1905

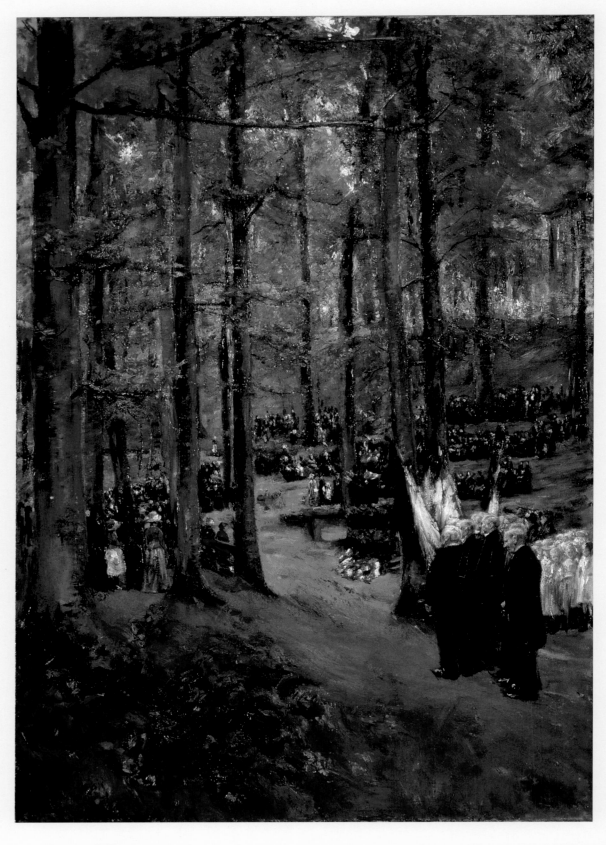

22 Max LIEBERMANN (1847–1935) *Memorial Service for Kaiser Friedrich at Kösen, 1888–9*

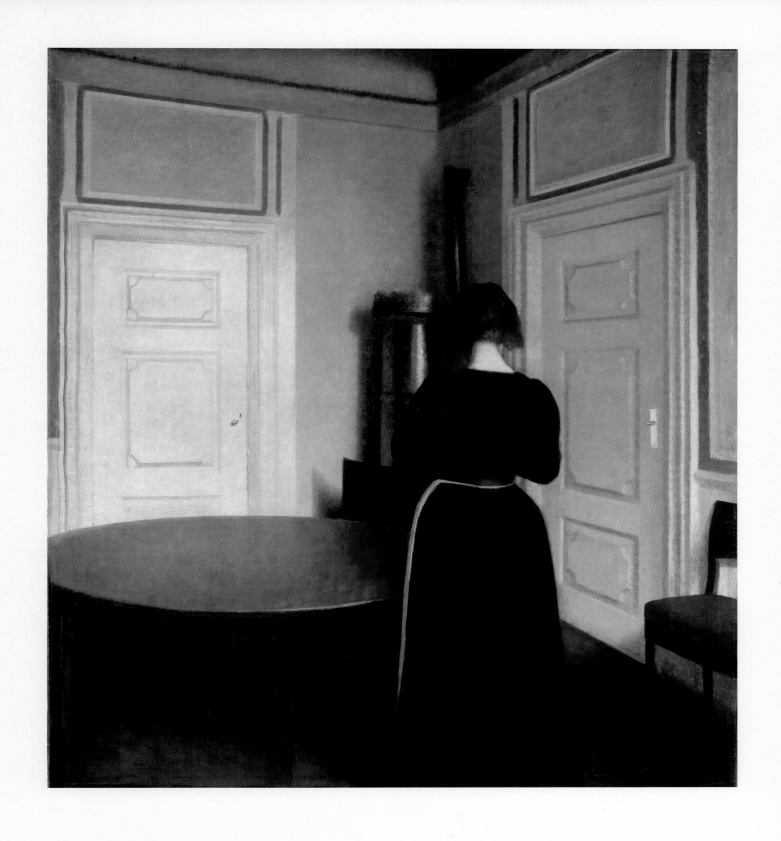

23 Vilhelm HAMMERSHØI (1864–1916) *Interior*, 1899

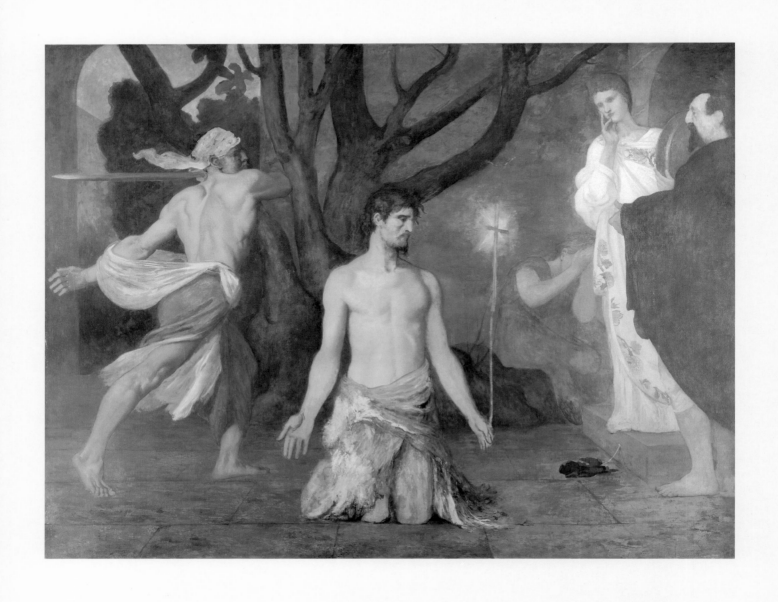

24 Pierre-Cécile PUVIS DE CHAVANNES (1824–1898) *The Beheading of Saint John the Baptist,* about 1869

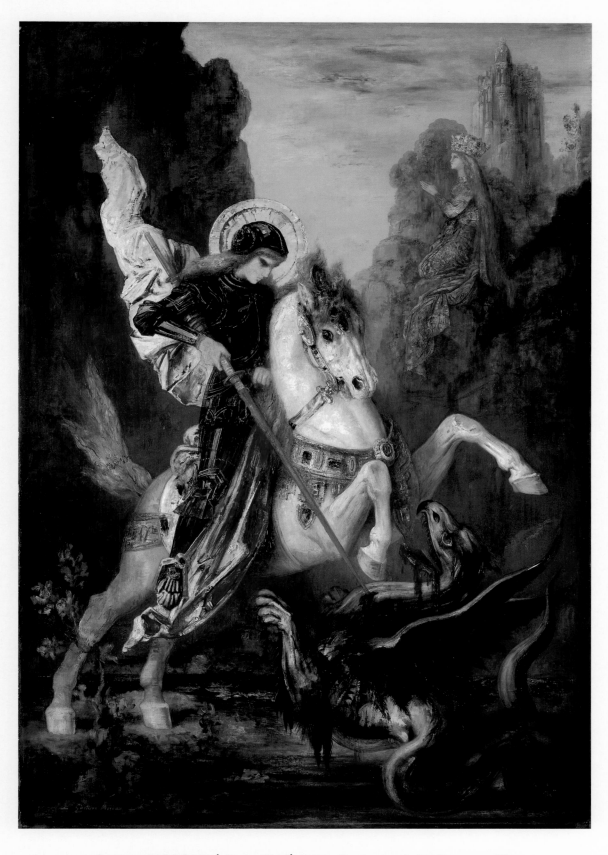

25 Gustave MOREAU (1826–1898) *Saint George and the Dragon*, 1889–90

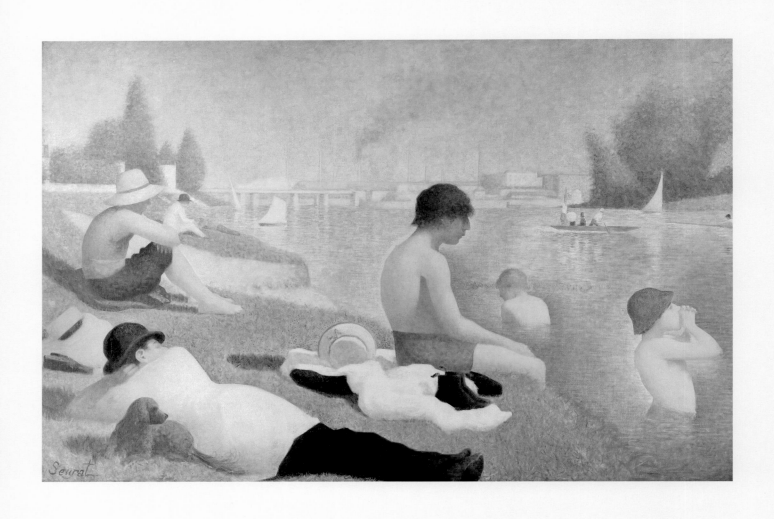

26　Georges SEURAT (1859–1891) *Bathers at Asnières*, 1884

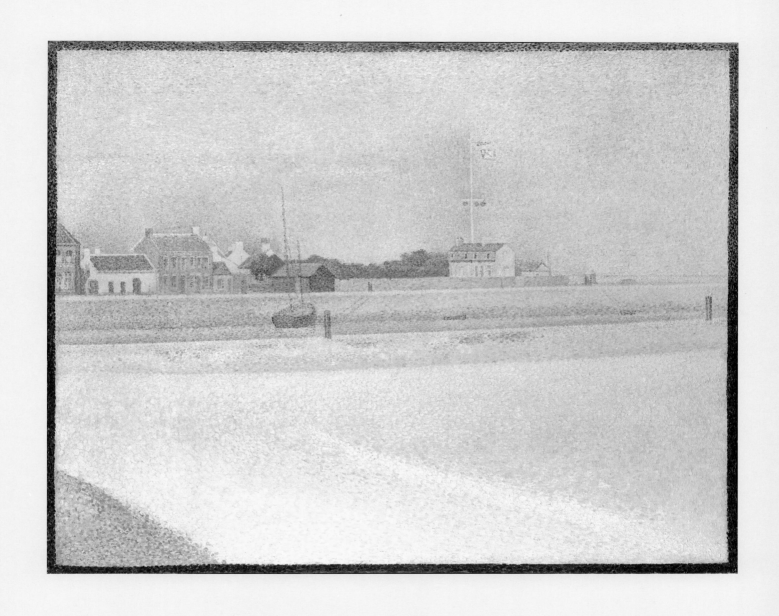

27 Georges SEURAT (1859–1891) *The Channel of Gravelines, Grand Fort-Philippe*, 1890

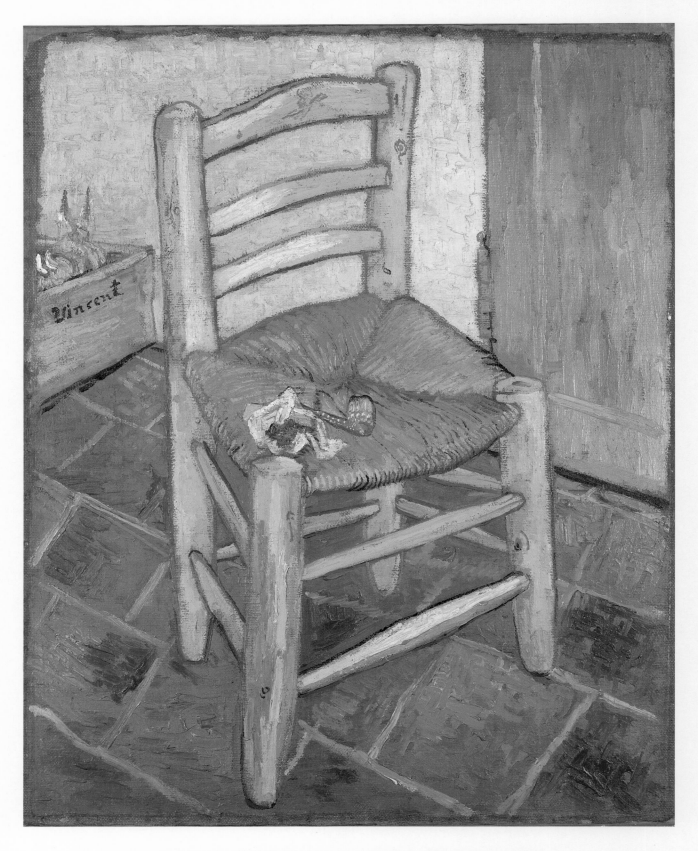

28 Vincent VAN GOGH (1853–1890) *Van Gogh's Chair*, 1888

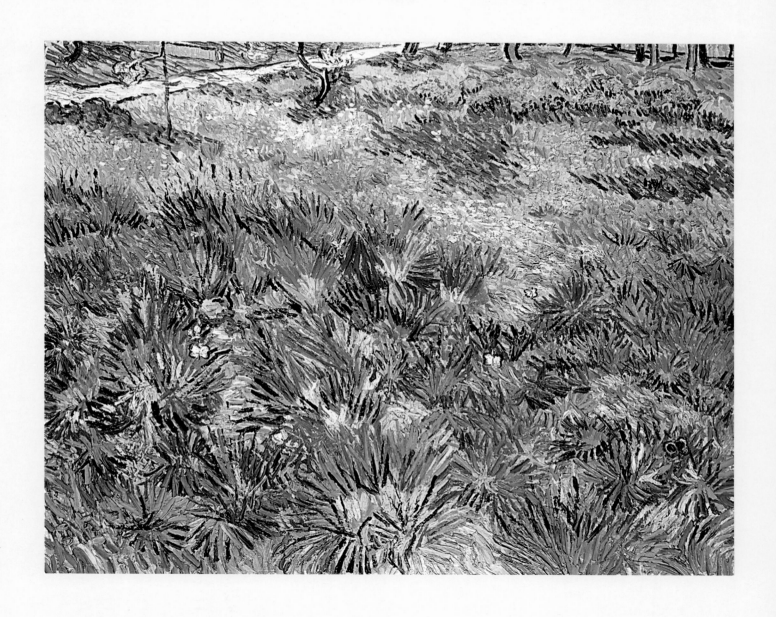

29 Vincent VAN GOGH (1853–1890) *Long Grass with Butterflies*, 1890

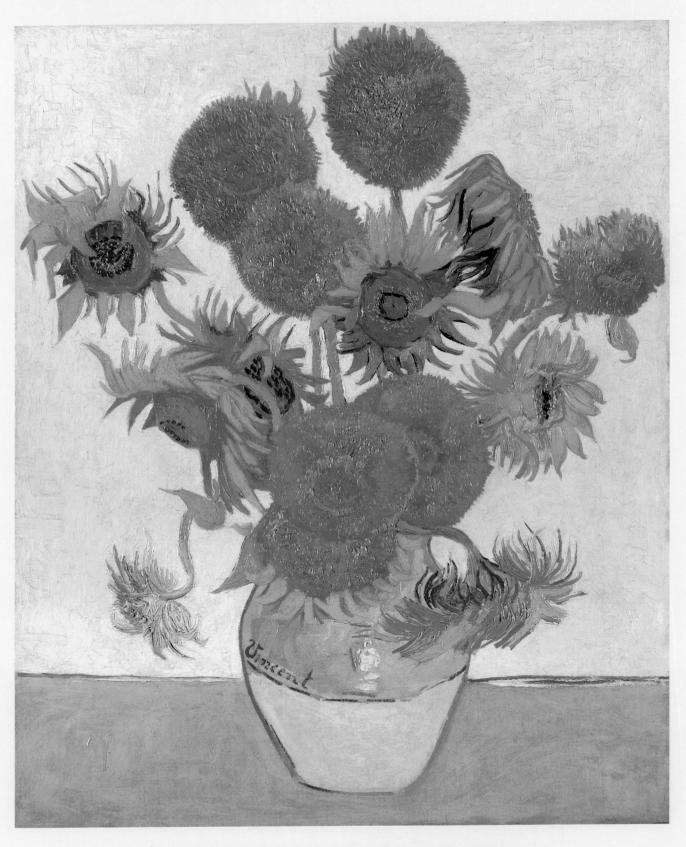

30 Vincent VAN GOGH (1853–1890) *Sunflowers*, 1888

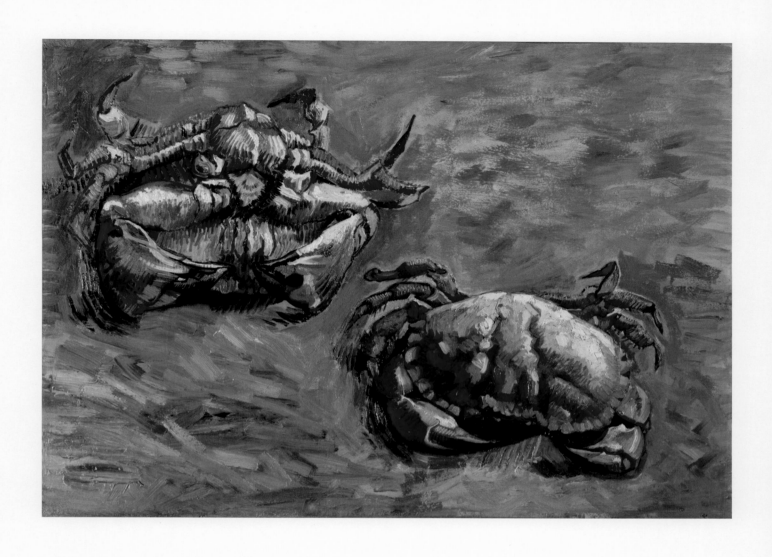

31 Vincent VAN GOGH (1853–1890) *Two Crabs*, 1889

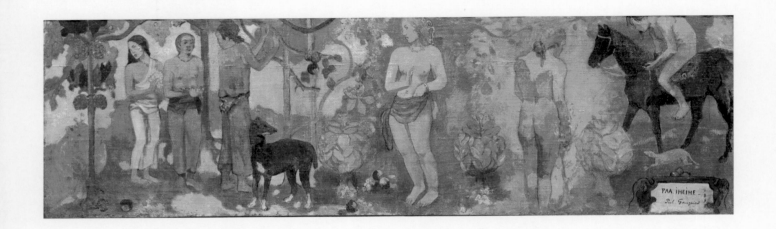

32 Paul GAUGIN (1848–1903) *Faa Iheihe*, 1898

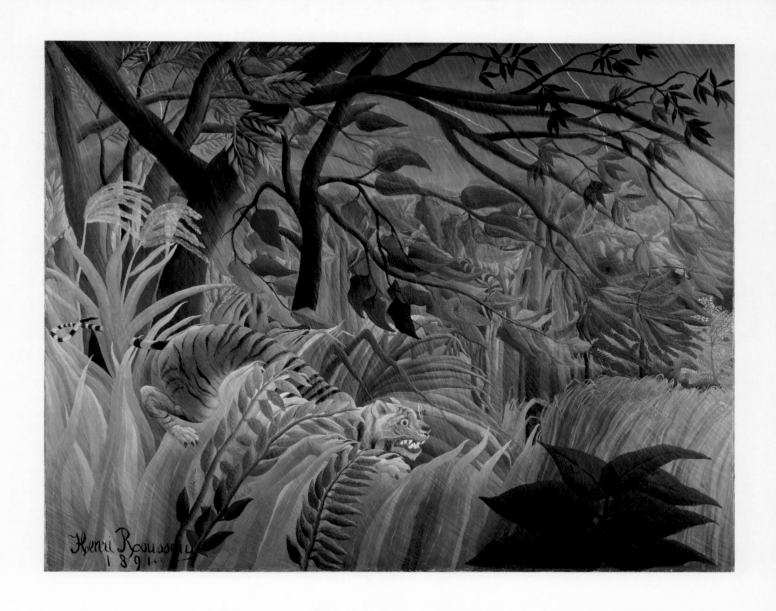

33 Henri ROUSSEAU (1844–1910) *Surprised!*, 1891

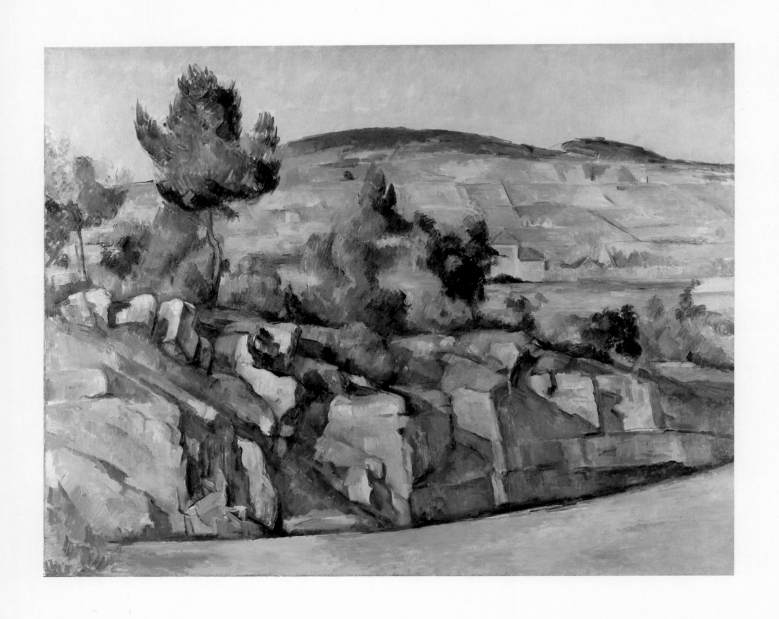

34 Paul CEZANNE (1839–1906) *Hillside in Provence*, about 1890–2

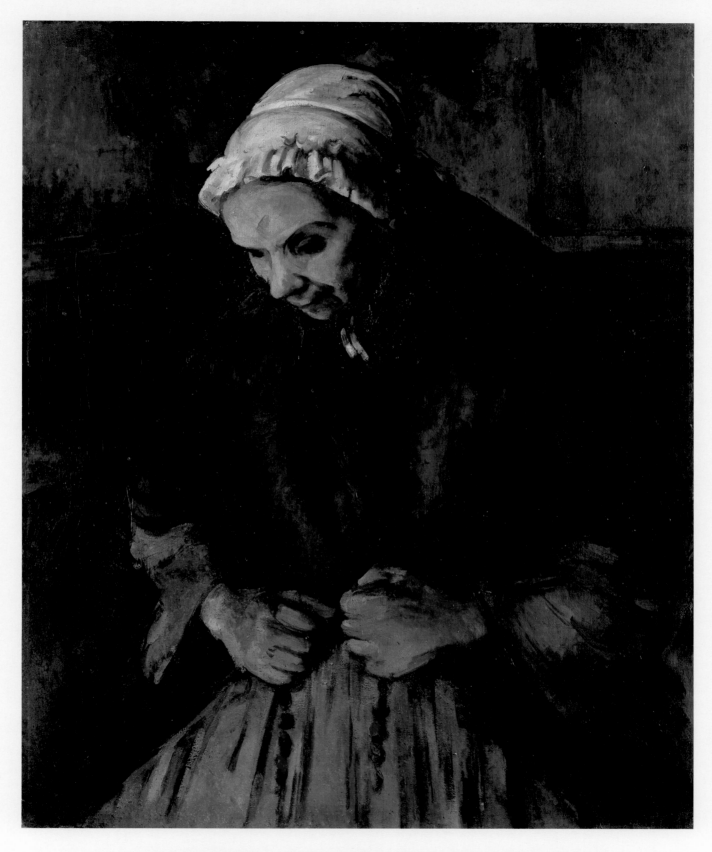

35 Paul CEZANNE (1839–1906) *An Old Woman with a Rosary*, about 1895–6

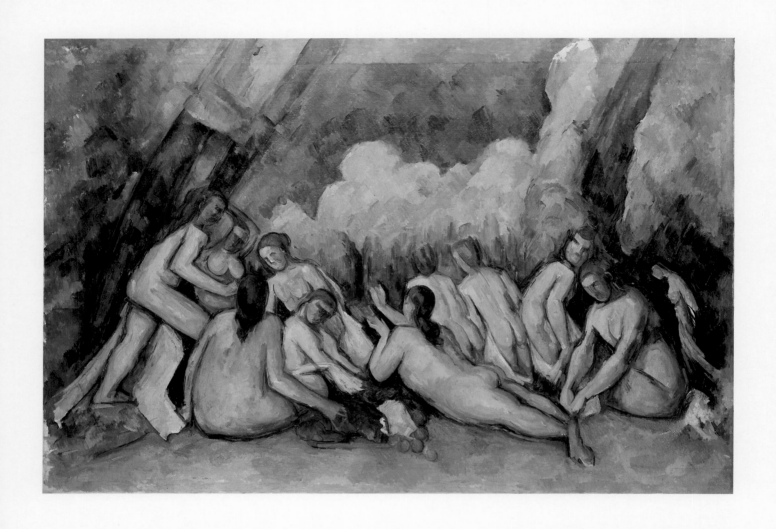

36 Paul CEZANNE (1839–1906) *Bathers (Les Grandes Baigneuses)*, about 1894–1905

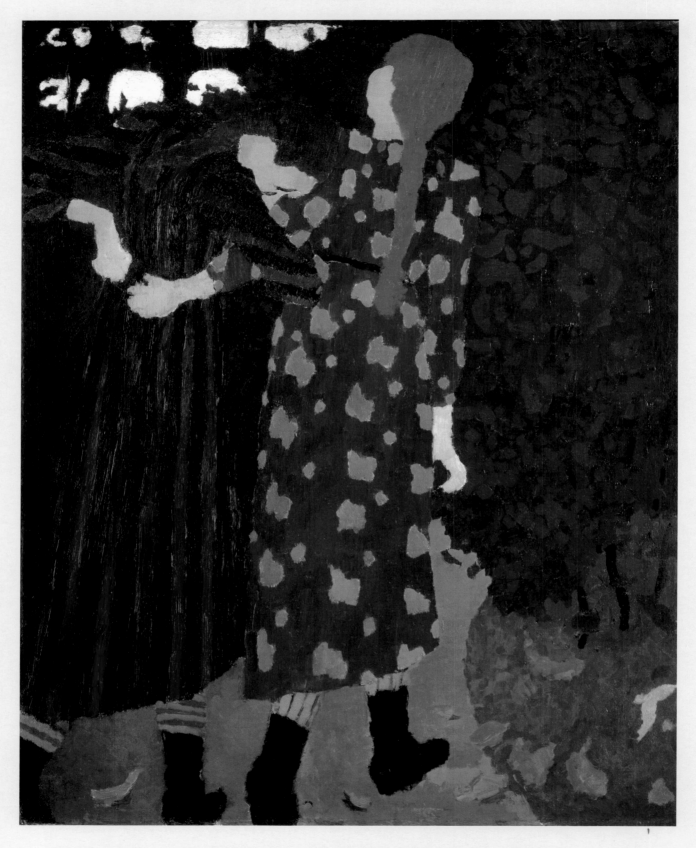

37 Edouard VUILLARD (1868–1940) *Young Girls walking*, 1891–2

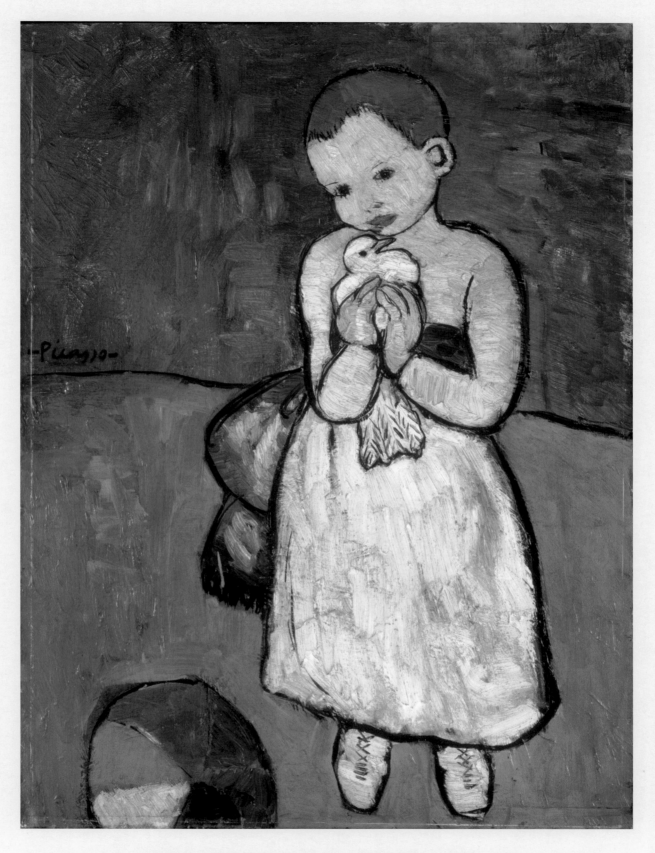

38　Pablo PICASSO (1881–1973) *Child with a Dove*, 1901

1 Edouard MANET (1832–1883)
 Music in the Tuileries Gardens, 1862
 Oil on canvas, 76.2 x 118.1 cm
 Sir Hugh Lane Bequest, 1917

Parisian courtly life under Emperor Napoléon III centred on the Tuileries Palace in the heart of the city. The gardens beyond the palace were also the scene of elegant gatherings in fine weather where military music was heard and gossip among the *beau monde* exchanged. Manet frequented the gardens, sketching friends and acquaintances and casting a cool appraising eye on the passing scene. In this work, one of his most audacious early paintings, he combined such studies with portraits based on *carte de visite* photographs to create a composite depiction of such an occasion, when the leading literary and artistic figures of contemporary Paris gathered. They include Baudelaire, Offenbach, Gautier and Fantin-Latour. Manet himself is there, top-hatted on the far left of the canvas, gazing out at the viewer. Several other figures remain unidentified. For Manet, modern urban life was comprised of such chance encounters and he was to be its foremost and most provocative chronicler, profoundly influencing the art of his younger admirers, the Impressionists.

CR

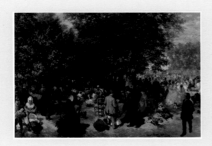

2 Adolph MENZEL (1815–1905)
 Afternoon in the Tuileries Gardens, 1867
 Oil on canvas, 49 x 70 cm
 Bought with grants from the American Friends of the National Gallery, London, and the George Beaumont Group, 2006

Like Manet, the German Menzel was committed to painting modern life in all its complexity and ambiguity. When he visited Paris in 1867 he probably saw Manet's *Music in the Tuileries Gardens* in an exhibition, and would have recognised that the two men shared artistic aspirations. Indeed, this painting can be seen as a response to Manet's; not only are subject matter and site similar, but the standing man in a top hat to the right here is all but a quotation from Manet's painting. Menzel, however, tells numerous little stories about the people who crowd the scene, in a way that Manet would have dismissed as anecdotal. When first exhibited late in 1867, the artist indicated that he had painted the picture from memory. He also signed it *Berlin* to underscore that it was the product not merely of observation, on which the painting of modern life must be based, but also of reflection over time as he sought to arrive at the deeper meaning of what he had seen.

CR

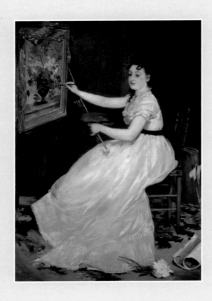

3 Edouard MANET (1832–1883)
Eva Gonzalès, 1870
Oil on canvas, 191.1 × 133.4 cm
Sir Hugh Lane Bequest, 1917

Eva Gonzalès (1849–1883) became Manet's only pupil in 1869. At the Salon of 1870 he exhibited this portrait of her, completed only after a large number of sittings. Berthe Morisot recounted his difficulties with the subject with some degree of irritation in letters to her sister: 'he has begun her portrait over again for the 25th time. She poses every day, and every night her head is washed out with soft soap ... As for now all his admiration is concentrated on Mlle Gonzalès, but her portrait does not progress; he says that he is at the fortieth sitting and that the head is once again effaced. He is the first to laugh about it...'

The depiction of Eva in a fine dress draws on the tradition of self portraits by women artists. She was later to paint a number of beautiful still-life paintings, yet the picture on the easel is more of a reference to Manet's own work in this genre.

SH

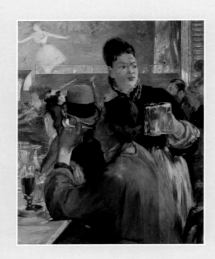

4 Edouard MANET (1832–1883)
Corner of a Café-Concert, probably 1878–80
Oil on canvas, 97.1 × 77.5 cm

In 1877, when a correspondent for an English newspaper saw this painting in Manet's studio, it looked quite different. It formed part of a larger canvas – a view of the *Reichshoffen Café-Concert* – that the artist divided into two smaller works the following year. The National Gallery picture occupied the right half of the composition while *In the Café*, now in the Oskar Reinhart Collection, Winterthur, was to the left.

Manet went on to make considerable changes to this part of the picture. The background of the original composition featured a singer on stage; a detail he altered twice before choosing to depict a dancer. Then, to the right side of the new image, he attached a supplementary stretch of canvas. The join it created is still visible today.

The construction of the work was highly contrived, but the woman it shows was a real waitress at the café-concert. She came to pose for the work accompanied by her 'protector': the man sitting before her in a blue smock. It is beside this figure, as if seated at the protruding table, that the viewer seems to enter the image.

NI

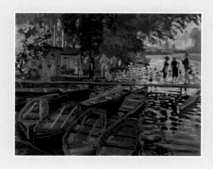

5　Claude-Oscar MONET (1840–1926)
Bathers at La Grenouillère, 1869
Oil on canvas, 73 × 92 cm
Bequeathed by Mrs M.S. Walzer as part of the Richard and Sophie Walzer
Bequest, 1979

The days in summer 1869 that Monet and Pierre-Auguste Renoir spent working side-by-side at La Grenouillère were decisive for the development of Impressionist painting. The site was a pleasure spot for bathing and *al fresco* dining along the Seine to the west of Paris, easily reached by train. It offered just the visual incidents the artists sought as they learnt to paint modern life: scenes of suburban leisure, sunlight glistening on the water, and animated shadows cast by rustling leaves. Both artists pushed themselves to new levels of experimentation, using touches of bright colour, applied directly with new freedom and authority.

Monet here uses large mosaic-like dabs of pure paint to build forms and delineate shadows and sunlight. He also calls on his skills as a caricaturist to swiftly capture the figures on the dock and the bobbing heads of swimmers beyond. For many people such beguiling images now represent the embodiment of Impressionist painting – but it was these paintings at La Grenouillère that revealed to Monet, Renoir and their colleagues the pictorial richness latent in such scenes, and first introduced the theme of suburban sociability that dominated Impressionist painting in following decades.

　CR

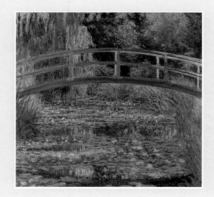

6　Claude-Oscar MONET (1840–1926)
The Water-Lily Pond, 1899
Oil on canvas, 88.3 × 93.1 cm

Monet created a Japanese-style water garden at his home in Giverny in 1893. Later in the decade, when the plants had matured, he began a series of paintings showing its bridge and water-lilies. However, as the muted brushstrokes and subtle colouration suggest, Monet's true subjects were the effects of light and weather. As he explained, in relation to his depictions of the pond, 'the water flowers are far from being the whole scene; really, they are just the accompaniment. The essence of the motif is the mirror of water whose appearance alters at every moment, thanks to the patches of sky that are reflected in it and which give it its life and movement'. Across the picture plane, to create a balanced pattern of light and dark, the artist used touches of similar colour. With this approach, Monet moved towards the increased abstraction that would characterise his later works.

　NI

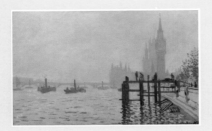

7 Claude-Oscar MONET (1840–1926)
The Thames below Westminster, about 1871
Oil on canvas, 47 × 72.5 cm
Bequeathed by Lord Astor of Hever, 1971

In 1870 Monet fled Paris and the Franco-Prussian war for London, whose river and parks provided new inspiration. Here he is looking upstream at the new Houses of Parliament and Westminster Bridge. On the right a few men dismantle a jetty probably used in the construction of the Victoria Embankment, seen on the far right. The rectangular building on the far left is St Thomas's Hospital, which opened in 1871.

Monet has painted thinly and sparingly in muted and serene colours. On the left the bridge is seen through the transparent paint of the boats. His emphasis on the formal elements of jetty, bridge and buildings heightens the decorative nature of the picture surface.

Monet was notorious for adding dates to his pictures many years later, and here his date of 1871 is in a different paint from the signature. In fact it is possible that he painted it a year earlier.

SH

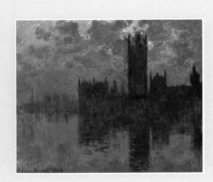

8 Claude-Oscar MONET (1840–1926)
Houses of Parliament, Sunset, 1902
Oil on canvas, 81.6 × 93 cm
On loan from a private collection, 2001

Monet's trip to London in 1870 was the first of many, culminating in three spectacular series; views of Charing Cross and Waterloo Bridge begun in 1899, and the Houses of Parliament, begun in 1900. He painted some nineteen pictures in this last series, working on the canvases both in London and back in his studio in Giverny.

Painting from a terrace at St Thomas's Hospital in late afternoon, he saw the buildings set against the setting sun, invariably through the atmosphere of London's infamous industrial fog. In a letter of 1920 Monet wrote: 'What I like most of all in London is the fog. Without the fog, London would not be a beautiful city. It's the fog that gives it its magnificent breadth'. In this painting, the buildings appear blue against the dramatic sky. The clock tower that houses Big Ben seems to be a magnet for swirls of light appearing like pink and violet lightning, the effects of the sunset breaking through a haze of coal smoke.

SH

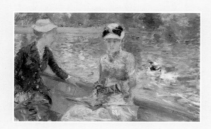

9 Berthe MORISOT (1841–1895)
Summer's Day, about 1879
Oil on canvas, 45.7 × 75.2 cm
Sir Hugh Lane Bequest, 1917

In 1880, when Morisot exhibited this canvas in the fifth Impressionist exhibition, it provoked mixed reactions. While one critic praised its subtle tones, claiming he had 'seen nothing more delicate in painting', others complained that her works were sketchy and unfinished. All, no doubt, were surprised by her innovative technique and unusual choice of colours. Distinctive zigzag markings fill the image with luminosity. The spontaneous strokes above and below the hands, which indicate shadow, also marry the dress of the model to the right with the water beyond.

Confined to the foreground, the models occupy a limited space: a reminder, perhaps, of the restricted existence women led in the nineteenth century. In a male dominated society, prevented from independent travel and excluded from many facets of city life, the female Impressionists focused often upon domestic subjects or familiar outdoor spaces. The popular *Bois de Boulogne,* the large park to the west of Paris where the painting is set, was one such location.

NI

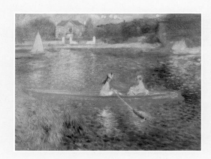

10 Pierre-Auguste RENOIR (1841–1919)
Boating on the Seine, 1875
Oil on canvas, 71 × 92 cm

The Impressionists are now well-known for favourite motifs such as the effects of light on water, Parisians at leisure, boating and steam trains crossing new iron bridges. Here Renoir combines all of these elements in a work probably executed at Chatou, a fashionable summer boating site on the Seine west of Paris that the artist visited often in the late 1870s. Two women float gently on a skiff in the sunshine. One turns to face the viewer; the other is absorbed in the peaceful atmosphere. The Seine, however, is the dominant motif. To achieve the extra-ordinary effect of shimmering sunlight on water, Renoir laid a white ground on the canvas before layering tiny flickering brushstrokes of colour over it. The train in the background reminds us how Parisians reached such leisure spots, and how the emerging technologies of the time fascinated the Impressionists.

CA

11 Pierre-Auguste RENOIR (1841–1919)
At the Theatre (La Première Sortie), 1876–7
Oil on canvas, 65 × 49.5 cm

Renoir and his Impressionist contemporaries were keen observers of the Parisian performing arts, devoting numerous canvases to depictions of café-concerts, cabarets, ballets and theatrical performances. Their attention was not always on the performers however: often they were just as fascinated by the audience and the social rituals of the theatre.

Here, Renoir looks at one such contemporary rite, *la première sortie*, or 'first outing', when a well brought-up girl, closely chaperoned, makes her appearance in a theatre box – announcing she was entering both young womanhood and polite society. The girl has not gone unobserved by members of the audience, who turn to gaze at her, perhaps hoping for an introduction. X-ray photographs show that Renoir initially intended to include two more figures in the box to the left of the foreground girl, but – always drawn to anecdote, and a brilliant editor of his own works – he changed his mind, painting them out to underscore the contrast between the girl in profile and her more distant admirers. The whole canvas is executed with Renoir's characteristic quick, sparkling and economic brushstrokes.

 CR

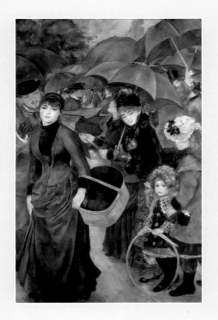

12 Pierre-Auguste RENOIR (1841–1919)
The Umbrellas, about 1881–6
Oil on canvas, 180.3 × 114.9 cm
Sir Hugh Lane Bequest, 1917

Renoir was a leading Impressionist painter during the 1870s and the one among his contemporaries most committed to depicting the human figure. The woman and child on the right of this beguiling canvas show how deftly his feathery, quick brushstrokes were able to suggest animation and the transient play of atmosphere. Over the next few years, however, Renoir experienced what can be called a crisis in his commitment to Impressionism. He came to worry that its effects were too fleeting and that such works lacked the gravity of painting worthy of museums. Mid-decade he returned to the canvas, repainting the left side, particularly the young woman with shopping basket, in his new, dryer and more muted style. The subject matter remains distinctively Impressionist, but the artist's touch has become stately and linear. That Renoir allowed the two styles to co-exist on the canvas, rather than repainting the entire composition, suggests that he saw the work as emblematic of the artistic struggle he had undergone during these years.

 CR

13 Camille PISSARRO (1830–1903)
The Avenue, Sydenham, 1871
Oil on canvas, 48 × 73 cm

In 1870, with the imminent threat of a Prussian invasion of France, Pissarro and many other artists left Paris for London. There, they found a highly industrialised capital, with suburbs that had developed rapidly. Perhaps, in view of the unrest back home, the peaceful life of such districts appealed. In this scene, as with the other works that he produced during his stay, the artist focused upon a prosperous residential area rather than the heart of the capital. The viewpoint he chose – so different to his bustling night scene of more than twenty years later – is still recognisable today.

Pissarro created his picture in a number of stages. He drew an outline, based on a preliminary watercolour, of the composition onto the canvas, which he filled in with blocks of paint. Then with wet strokes of colour he worked across the whole image to unite its various elements. Lastly – and most probably in the studio – he added the clusters of figures. The group directly in front of the church, which replaced a lone female character, was a particularly late inclusion.

NI

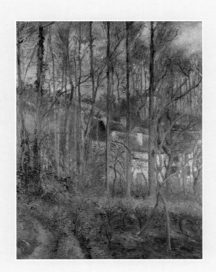

14 Camille PISSARRO (1830–1903)
The Côte des Bœufs at L'Hermitage, 1877
Oil on canvas, 114.9 × 87.6 cm
Presented by C.S. Carstairs to Tate through The Art Fund, 1926;
transferred, 1950

Just moments from his home in *L'Hermitage,* not far from Paris, the *Côte des Bœufs* provided Pissarro with an ideal rural motif. Like many of his Impressionist contemporaries he was preoccupied with the idea of painting landscapes outdoors and turned to the outskirts of the city for inspiration. It seems likely that he made this picture in front of his subject, though the heavily worked surface of the canvas suggests it took several sessions to complete.

1877 was a year of great formal experimentation for Pissarro. The network of small brushstrokes, layered in different directions, provides evidence of his search to best capture the scene. Though there are many different tones visible, perhaps to unify the overall composition, he used a limited range of colours. Once completed, the artist was particularly fond of the painting: it decorated his bedroom for several years.

NI

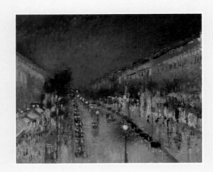

15 Camille PISSARRO (1830–1903)
The Boulevard Montmartre at Night, 1897
Oil on canvas, 55.3 x 64.8 cm

'I have begun my series of boulevards; I have an extraordinary motif that is going to need interpreting in every possible light' wrote Pissarro to his son Georges in February 1897. He had found a perfect subject for a modern artist; the *Boulevard Montmartre* typified the controversial redevelopment of Paris carried out by Baron Haussmann in the 1850s and 1860s. Furthermore, as his art dealer Paul Durand-Ruel had suggested, buyers found such cityscapes attractive.

Pissarro hired a hotel room with a clear view of the thoroughfare. He made several paintings from its window over the following weeks. Clearly, as his vibrant portrayal of the crowd on the café-lined pavement suggests, the artist brought considerable energy and enthusiasm to the project. Many works from the series explored effects of weather and traffic, but this night scene was unique. Here the gaslights stand out against the muted tones of the wet pavement. Like beacons, haloed by dynamic brushstrokes, they lead the viewer into the composition.

NI

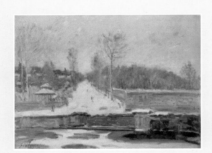

16 Alfred SISLEY (1839–1899)
The Watering Place at Marly-le-Roi, probably 1875
Oil on canvas, 49.5 x 65.4 cm

The Château de Marly, constructed for Louis XIV in the late seventeenth century, had been famous for its water gardens of fountains, cascades and a series of terraced pools. The Château was demolished in 1793 during the French Revolution, but some vestiges of the gardens remained, including the watering place (or *l'abreuvoir*), which acted as an overflow on the edge of the park.

Sisley lived in Marly-le-Roi from early 1875 until 1877, at 2 route de l'Abreuvoir. During 1875–6 he depicted the watering place in at least a dozen paintings. Here it is frozen and covered in snow apart from a small area on the right under the water outlet, from which water flows. It was painted mostly on the spot, rapidly and thinly, so that the ground colour, a layer of white tinted with brown, is visible throughout the picture. In the sky it forms the principal tone, conveying the impression of leaden winter clouds.

SH

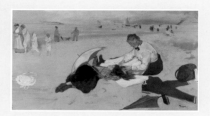

17 Hilaire-Germain-Edgar DEGAS (1834–1917)
Beach Scene, about 1869–70
Oil (essence) on paper on canvas, 47.5 × 82.9 cm
Sir Hugh Lane Bequest, 1917

In the foreground a nurse combs the hair of a little girl after her swim. Her swimming costume is laid out to dry like a paper cutout for a dress-up doll.

Degas stated that this was a studio composition: 'It was quite simple. I spread my flannel vest on the floor of the studio and had the model sit on it. You see, the air you breathe in a picture is not necessarily the same as the air out of doors.' It is painted in essence, an oil medium thinned with turpentine that results in a thin, clear wash, and is composed on three separate pieces of paper mounted onto canvas. Above the two central figures, and visible even to the naked eye, is a drawing of large wheel-like shapes on 'tracks', with ruled horizontal and vertical lines receding to the top of the picture. It is possible that these are the beginnings of large-wheeled bathing machines (huts on wheels used to protect bathers from prying eyes), which Degas ultimately decided not to include.

SH

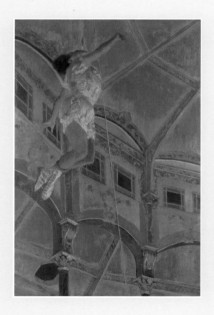

18 Hilaire-Germain-Edgar DEGAS (1834–1917)
Miss La La at the Cirque Fernando, 1879
Oil on canvas, 117.2 × 77.5 cm

Miss La La was a mixed-race circus performer renowned for her acts of strength. One of these involved firing a cannon on a chain suspended from her teeth, for which she was nicknamed 'La Femme Canon'.

Here we are shown her no-less-extraordinary feat of being hoisted to the roof of the circus on a chain held in her mouth. The setting is the Cirque Fernando close to Degas's home in Montmartre, which he visited on a number of occasions in January 1879 to make studies of her. He quickly settled on her pose, seen from below, but had difficulty placing her within the architecture of the building, as shown by the multiple drawn lines that lie beneath the paint surface. It appears that he even had to enlist help, as he informed the artist Walter Sickert that he hired a professional to draw the architecture for him, probably on a separate drawing that Degas then copied.

SH

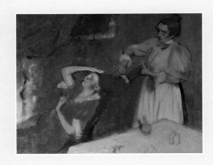

19 Hilaire-Germain-Edgar DEGAS (1834–1917)
Combing the Hair ('La Coiffure'), about 1896
Oil on canvas, 114.3 x 146.7 cm

A woman having her hair combed by a maid was a favourite subject for Degas in his later years. This version is particularly striking for its bravura handling and intensity of colouring, ranging from the orange surrounding the maid to the bright scarlet of the woman's dress and the deep crimson of her chair.

At some point Degas decided to enlarge the canvas onto a bigger stretcher, adding a large strip of bare canvas at the bottom, complete with tacking holes. However, he never covered up this strip, and so the painting appeared like this in his studio sale of 1918. The National Gallery was initially interested in buying the picture but struck it off its list due to its unfinished appearance. The painting was later returned to its original size, perhaps when it was in the collection of Henri Matisse. In any case, when Matisse's son offered it to the National Gallery in 1937, it was judged suitable for purchase.

SH

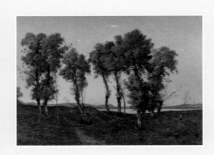

20 Henri-Joseph HARPIGNIES (1819–1916)
Autumn Evening, 1894
Oil on canvas, 116.8 x 160 cm
Bequeathed by Pandeli Ralli, 1928

In later life Harpignies increasingly painted in the south of France. He spent the winter of 1893–4 in Nice, and he probably painted this view near the city.

A group of trees stand on undulating grassy land in front of a lake with hills beyond. The foreground paint is heavily textured with multi-directional strokes in different greens suggesting profuse low-lying vegetation. Dark brown paint reinforces the lines of the tree trunks and adds further branches, lending them a presence that contrasts with the misty outlines of the foliage. Drawing lines are visible all over the picture, appearing muted under the paint of the sky. Harpignies's dominant influence was Jean-Baptiste-Camille Corot, and the foliage owes a debt to that master, but the crystalline light that characterises so many of Harpignies's paintings could not be more different from the famous misty silvery light of his mentor.

SH

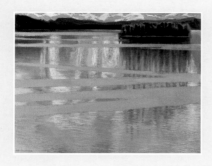

21 Akseli GALLEN-KALLELA (1865–1931)
Lake Keitele, 1905
Oil on canvas, 53 x 66 cm

Gallen-Kallela was the leading Finnish exponent of Modernism in painting. After training in Paris and exhibiting extensively abroad, he was keenly aware of avant-garde currents at the turn of the twentieth century, not least the innovations, in terms of bright colour and decorative patterning of the picture plane, introduced by Gauguin. Gallen-Kallela's achievement was to wed these formal qualities to emerging Finnish nationalist sensibilities, forging an art that was unmistakeably Finnish in subject matter but international in style and technique.

Lake Keitele is one of the countless bodies of water that dot the Finnish wilderness. The artist often retreated there from Helsinki to reconnect with nature. For Gallen-Kallela (who signed the canvas with the Swedish form of his name, Axel Gallèn) the site was inhabited by the heroes of Finland's medieval epic, the *Kalevala.* Here, Väinämöinen, the mythic builder of boats, has just rowed past leaving a silvery wake in his path. A pure landscape of the mystic north, the picture is at the same time a clarion call to Finnish pride.

CR

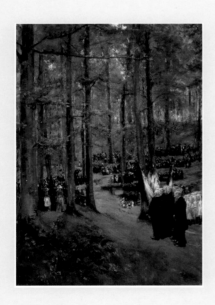

22 Max LIEBERMANN (1847–1935)
Memorial Service for Kaiser Friedrich at Kösen, 1888–9
Oil on canvas, 93 x 64.1 cm
On loan from Tate since 1997

Outdoors, beneath a canopy of trees, a congregation marks the end of the briefest of reigns. Kaiser Friedrich, whose accession took place in June 1888, had spent just three months on the throne before succumbing to cancer. The subject made for an image imbued with pathos and quiet.

Although the picture invites the viewer to join the memorial service, the artist did not attend the event he depicted. Instead, in his Berlin studio, he developed his composition from a series of studies he made in Kösn that spring. But the painting was not based solely on his own work. Visits to Barbizon and the Netherlands in the 1870s had given him a taste for painting woodland scenes; the thickness of the paint and the muted palette also recall the work of Courbet. Sensitive to the achievements of German artists, too, Liebermann took further inspiration from a well-known painting by Menzel entitled *Mission Service in the Beech Wood at Kösen.*

NI

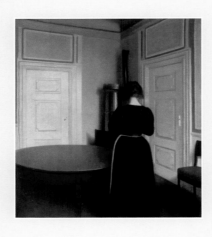

23 Vilhelm HAMMERSHØI (1864–1916)
Interior, 1899
Oil on canvas, 64.5 x 58.1 cm
Presented in memory of Leonard Borwick by his friends through
The Art Fund, 1926. On loan from Tate

Hammershøi was a leading artist in his native Copenhagen at the turn of the twentieth century. His early works in particular sometimes caused controversy there but his reputation declined after death as the calm, almost monochromatic canvases for which he was most famous came to seem old-fashioned and overly fastidious. Only in recent decades has he found new champions, first among Danish critics and then abroad, who recognise him as one of the most original Scandinavian artists of his day, acutely observant of the mysteries of everyday life.

One of Hammershøi's constant subjects, seen in more than sixty paintings, was the austere interior of his apartment at Strandgade 30, Copenhagen. Often, as here, it is inhabited by the solitary figure of the artist's wife, Ida, frequently shown from the rear as she goes about her slow, serene domestic rituals. Many have compared the tranquillity of such works to the paintings of Vermeer. Hammershøi, who travelled extensively and had a wide acquaintance, gave this painting to an English musician friend, Leonard Borwick.

CR

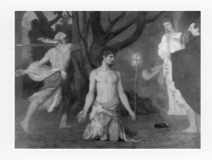

24 Pierre-Cécile PUVIS DE CHAVANNES (1824–1898)
The Beheading of Saint John the Baptist, about 1869
Oil on canvas, 240 x 316.2 cm
Sir Hugh Lane Bequest, 1917

After Salome enchanted her stepfather, Herod Antipas, the King of Israel, with her dancing, he offered her any gift she desired. On the advice of her mother she requested that the head of John the Baptist be delivered to her on a golden platter (Mark 6). Despite reservations, Herod ordered the preacher's execution and Puvis depicts the moment just before decapitation. John kneels facing us, his gaze turned to the cross emitting a divine light. The composition contrasts the Baptist's composure with the dynamism of the executioner, while Salome, platter in hand, stands on the right next to Herod. Both appear as detached from the action as John – only the seated woman, weeping, shows any emotion. Puvis exhibited a smaller version of this painting at the Salon in Paris but kept this canvas in his possession all his life. It may be unfinished.

CA

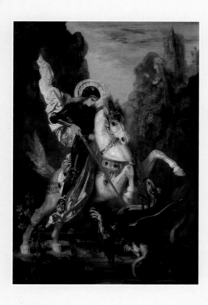

25 Gustave MOREAU (1826–1898)
Saint George and the Dragon, 1889–90
Oil on canvas, 141 x 96.5 cm

The medieval story of the soldier-saint George, who saved a princess from a dragon, was one of the many religious episodes that Moreau chose to depict. Beyond its Christian significance the episode provided the artist with a model to explore more personal concerns; the theme of good overcoming evil must have seemed particularly relevant at a time when his muse, Alexandre Dureux, was severely ill.

In Moreau's rendition of the scene, with its subdued shades of gold and brown, the figure of the princess is distant and ephemeral. Meanwhile, in the foreground of the image, Saint George spears the beast. Perhaps his depiction of the saint's efforts to protect the princess pre-empted the sentiments that Moreau expressed when Dureux died in 1890. At that moment, in a prayer that he wrote for her, he asked God to grant her peace in return for his own good conduct on earth.

NI

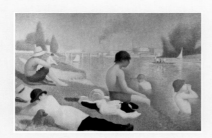

26 Georges SEURAT (1859–1891)
Bathers at Asnières, 1884
Oil on canvas, 201 x 300 cm

Bathers is Seurat's first large-scale canvas, painted when he was twenty-four. The subject was modern, showing a group of working men and boys taking a rest on the banks of the Seine in Asnières, a suburb north of Paris, but Seurat gives the scene the monumental treatment of a history painting. He followed standard academic procedure in making large numbers of drawings and oil studies to map out the composition. Each figure was the subject of a drawing. In the painting they remain separate, isolated even, impervious to the others' presence.

The painting demonstrates Seurat's interest in scientific colour theory, particularly the interaction of complementary and contrasting colours: in the foreground shadow the purple touches contrast with the yellow in the surrounding sunlit grass. Most of the painting is executed in short, multi-directional strokes, but in about 1886–7 he returned to the picture, adding dots of colour (principally to the foreground bathers and their surroundings), to demonstrate his newly practised technique of optical mixing.

SH

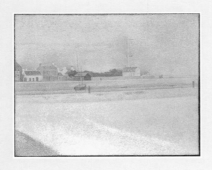

27 Georges SEURAT (1859–1891)
The Channel of Gravelines, Grand Fort-Philippe, 1890
Oil on canvas, 65 x 81 cm
Bought with the aid of a grant from the Heritage Lottery Fund, 1995

Seurat spent his last summer at Gravelines, a small port on the north coast of France close to the Belgian border. He painted four views of the two hamlets Grand Fort Philippe and Petit Fort Philippe, which flank the narrow channel linking the port with the sea. This view is from Petit Fort Philippe, looking across the expanse of sandy beach at low tide. On the other side of channel the semaphore flags are warning of shallow harbour waters.

These last four works were remarkable for their sense of order and design. Here a sequence of diagonal lines creates a calm and ordered composition devoid of any human presence. The seemingly vast expanse of sand is in fact broken up by a myriad of subtle gradations of colour. These paintings were the last Seurat painted with borders, which were graduated to complement the colours of the canvas, for example the orange at the top next to the blue of the sky.

SH

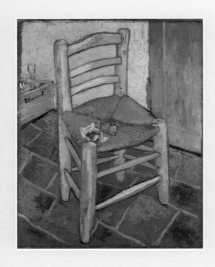

28 Vincent VAN GOGH (1853–1890)
Van Gogh's Chair, 1888
Oil on canvas, 91.8 x 73 cm

The sparse interior shown in this painting belonged to the house that Van Gogh rented in Arles. It was there, in the autumn of 1888, that Paul Gauguin joined him for two months. In honour of the visit Van Gogh decorated the guest room, complete with an ornate armchair. Then he made two paintings: one of the chair in Gauguin's room and another, which featured his own chair. The pieces of furniture, in the respective images, conveyed the contrasting personalities of the different artists.

Van Gogh considered himself artistically inferior to Gauguin: a feeling emphasised by his choice of a simple kitchen chair as a vehicle of self-expression. A crate of onions in the background, meanwhile, gives an impression of rustic domesticity. In formal terms, however, the painting is sophisticated. Contrasting shades of green and yellow, applied in confident brushstrokes, animate the image. The placement of the chair – at variance with the floor beneath – seems to anticipate effects seen in the Cubist still lifes of the early twentieth century.

NI

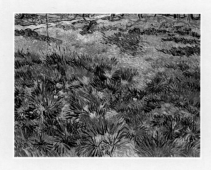

29 Vincent VAN GOGH (1853–1890)
Long Grass with Butterflies, 1890
Oil on canvas, 64.5 x 80.7 cm

Van Gogh had been in Saint-Paul Hospital at St-Rémy, near Arles, for about a year when he painted this landscape in spring 1890. It depicts an overgrown corner of the asylum garden; a few white butterflies flit among the tall blades of grass and spring flowers – accents of red that may have faded over the years. Most audacious is the point of view, looking downwards – and forcing us to do so as well – so that the whole canvas is taken up by grass, without the horizon that a more conventional, less daring landscape artist would have included.

The space seems infinitely extendable; one can feel slightly unsteady on one's feet when in front of it. A few moments study establishes, however, that Van Gogh created a convincing sense of spatial recession by reducing the size of the brush-strokes at the top of the canvas, and by placing a path and a tree stump along the upper edge. Several of Van Gogh's final works experiment with such spatial manipulations, and the 'overall' painting style he developed here proved influential to painters in later decades.

SH

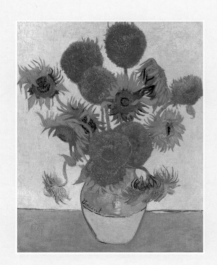

30 Vincent VAN GOGH (1853–1890)
Sunflowers, 1888
Oil on canvas, 92.1 x 73 cm

In August 1888 Vincent wrote to his brother Theo about a series of sunflower paintings for his rented house in Arles in southern France: 'I am hard at it, painting with the enthusiasm of a Marseillais eating bouillabaisse, which won't surprise you when you know that what I'm at is the painting of some big sunflowers. I have three canvases going ... I am working at it every morning from sunrise on, for the flowers fade so soon, and the thing is to do the whole in one rush.' He envisaged twelve paintings, but in the event only four were painted that month, of which this was the last, the first to set the yellow flowers against a yellow background. It was one of two hung in the guest room in anticipation of Gauguin's arrival in October that year.

Sunflowers traditionally symbolised love and fidelity, both religious and secular. For Van Gogh they further represented gratitude. His deep feeling for the flower led him to state to Theo: '... the sunflower is mine in a way.'

SH

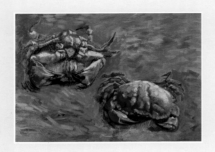

31 Vincent VAN GOGH (1853–1890)
Two Crabs, 1889
Oil on canvas, 47 x 61 cm
On loan from a private collection

After his argument with Gauguin in 1888 – the infamous incident in which he cut off part of his ear – Van Gogh began 1889 in hospital. None the less, upon discharge, he returned immediately to his art. 'I shall begin by doing one or two still lifes,' he explained to his brother, 'so as to get back in the habit of painting.' This unusual image may be one of these works.

The inspiration for Van Gogh's distinctive choice of subject could have been a woodcut, also of a crab, by the Japanese printmaker Hokusai. Japanese prints were particularly fashionable in the late nineteenth century and several decorated the artist's studio. The evident interest in texture, however, suggests that this image was developed from study of a real animal. Perhaps Van Gogh painted the same crab twice: the composition details both the soft underside and the hard outer shell. Such a practice would reflect how, even if Van Gogh envied Hokusai's imaginative powers, he believed that working from life produced the best results.

NI

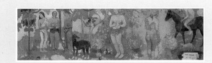

32 Paul GAUGIN (1848–1903)
Faa Iheihe, 1898
Oil on canvas, 54 x 169.5 cm
On loan from Tate since 1997

From his first visit to the South Seas, until his death there in 1903, Gauguin was fascinated by the sensuality of the local people. The themes of adornment and grooming in this work – alluded to in its mispelt Polynesian title – were no doubt inspired by looks and customs that he found profoundly exotic.

Gauguin's interest in the remote islands was shaped by contemporary preconceptions about different cultures. Accordingly, although he could have drawn upon the daily life he would have witnessed, the artist chose an elongated format reminiscent of indigenous wooden relief carvings to describe his subject on canvas. Likewise, the gesture of the central figure – with her upright hand placed between her breasts – is from a Javanese sculptured frieze, even though her general appearance suggests she was based upon a real, contemporary, model. Albeit inadvertently, then, this image reveals far more about a French painter's idyllic fantasy than it does about turn-of-the century life in Tahiti.

NI

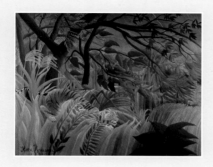

33 Henri ROUSSEAU (1844–1910)
Surprised!, 1891
Oil on canvas, 129.8 x 161.9 cm
Bought, with the aid of a substantial donation from the
Hon. Walter H. Annenberg, 1972

This arresting image of a tiger in a tropical storm was the first of Rousseau's jungle paintings. Later, the genre would make him famous, but in 1891 he was still an amateur artist. Obliged to hold down a day job in the civil service, in his spare time he visited the zoos and hothouses of Paris. It was there that he saw the animals and plants that inspired his exotic visions.

Rejected by the official salon, Rousseau displayed his efforts at the *Salon des Indépendants*, where all exhibitors were welcome upon payment of a small fee. There, though the reactions it provoked were largely negative, his canvas attracted the attention of the Swiss painter Felix Vallotton. 'Before such childish naivety', he wrote, 'even the most deep-rooted convictions are held up and questioned.' It may have been this challenge – as well as the vibrant colour and bold use of line – that made Rousseau's work important for artists including Picasso and Kandinsky.

NI

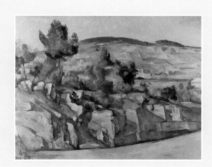

34 Paul CEZANNE (1839–1906)
Hillside in Provence, about 1890–2
Oil on canvas, 63.5 x 79.4 cm
Bought by the Trustees of the Courtauld Fund, 1926

Cézanne reportedly wrote: 'In order to paint a landscape well, I first need to discover its geological structure … I need to know some geology … since such things move me, benefit me.' It is likely that he was taught about the Aix country-side by his friend the geologist Fortuné Marion (an amateur painter), and Cézanne seems to have had a special understanding of the geological specificities of the region, particularly evident in this painting that shows a rocky escarpment at the side of a road. The artist's knowledge of the landscape's underlying structure and harmony adds to the sense of permanence and monumentality.

Seemingly simple, the painting possesses the immediacy of a canvas executed in the open air, but it results from calculated preparation. The original pale blond priming is still visible, which contributes to the painting's overall tone. In places, some faint pencil lines can be seen, revealing that Cézanne first sketched out the design on the canvas, before laying it in with parallel strokes of paint.

AR

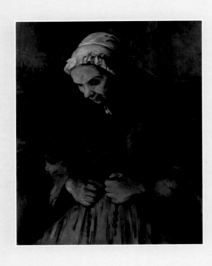

35 Paul CEZANNE (1839–1906)
An Old Woman with a Rosary, about 1895–6
Oil on canvas, 80.6 x 65.5 cm

This remarkable portrait shows an old woman looking remote and disengaged. Her gnarled hands fumble with her rosary, busily clutching at its beads – but rather than praying fervently, she looks as though she is mumbling her litanies obsessively, resigned and disconnected. Under a raised eyebrow her vacant look betrays dementia.

There is little sentimentality or compassion here; Cézanne is more interested in the formal potential offered by her hunched posture and bony, angular features, which are inscribed in a network of intersecting diagonals. The thick and encrusted paint indicates that the artist worked on the canvas repeatedly, but it must have ultimately left him dissatisfied, as he discarded the painting. It was later found by Cézanne's friend and biographer Joachim Gasquet, who wrote 'When the canvas was finished he chucked it into a corner. It got covered with dust ... I came upon it under the coalscuttle by the stove ... What miracle had preserved it intact I don't know. I cleaned it, and the poor old girl appeared before me.'

AR

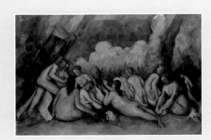

36 Paul CEZANNE (1839–1906)
Bathers (Les Grandes Baigneuses), about 1894–1905
Oil on canvas, 127.2 x 196.1 cm
Purchased with a special grant and the aid of the Max Rayne Foundation, 1964

During his last years Cézanne embarked on three large canvases showing bathers, the culmination of his life-long investigation of the theme. Considerably larger than any of his other works, these reflected his fascination with Renaissance and post-Renaissance painting, reflecting the long tradition of depicting nude figures in an idealised landscape. The precise dating of the three paintings, and the sequence in which they were made is the source of much speculation. Commencing the project in the mid-1890s, Cézanne probably alternated between the paintings, although this work is generally acknowledged to be the second he began.

Bathed in vivid, pearlescent light, the female figures are outlined in deep blue to enhance the milky quality of their flesh. Those to the left adapt their unorthodox poses to the pattern of the trees behind them. Cézanne frequently distorted the bodies of his figures – a process which reaches a climax here. These deformations may not be entirely deliberate; Cézanne confessed he would rather have used a model, but was too shy to do so.

AR

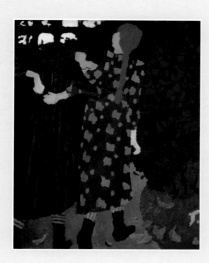

37 Edouard VUILLARD (1868–1940)
Young Girls walking, 1891–2
Oil on canvas, 81.2 x 65 cm
On loan from a private collection

Vuillard's painting was at its most experimental in the 1890s when he was influenced deeply by the innovations of Paul Gauguin. Working alongside his fellow Nabis, or 'prophets', the half-joking title some Gauguin adepts coined for themselves, Vuillard melded a decorative, flattened pictorial space with an emotional intensity. However, whereas Gauguin sought out the exotic and primitive, Vuillard lived with his mother and sister in an urban Paris flat.

Here, two girls stroll in a small Paris park, probably the Square Berlioz not far from Vuillard's studio. They could be school friends or shop girls on a break, and the picture is full of light, witty touches (such as the contrasting patterns of dresses and stockings), but at the same time, something in the girls' averted gazes – as if they are scurrying away from us – and the strange melded forms, hints that ambiguous emotions are inarticulately in play. Vuillard was an exponent of the contemporary Norwegian playwright Henrik Ibsen's psychological dramas, later designing sets and playbills for several productions of his works.

CR

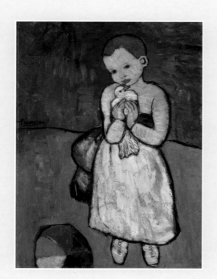

38 Pablo PICASSO (1881–1973)
Child with a Dove, 1901
Oil on canvas, 73 x 54 cm
On loan from a private collection since 1974

A young girl cradles a dove in her hands. Shoulders hunched, head turned slightly, she shies away from the viewer. In this work, painted at a transitional moment in Picasso's career, a sense of melancholy pervades. Perhaps it is unsurprising that the picture has attracted biographical interpretations: Picasso's sister, aged only 7, had died in 1895.

But, beyond any personal significance, the work tells another story. It reveals that Picasso had responded to the new painting he saw in Paris. The distinctive outlines around the forms recall those used by Gauguin; devoid of spatial recession, the sparse background is reminiscent of compositions by Puvis de Chavannes. To create an innovative image of his own, it seems, Picasso drew on recent developments. He responded to the art of his time in ways appropriate to the age: as Manet had done over thirty years previously.

NI